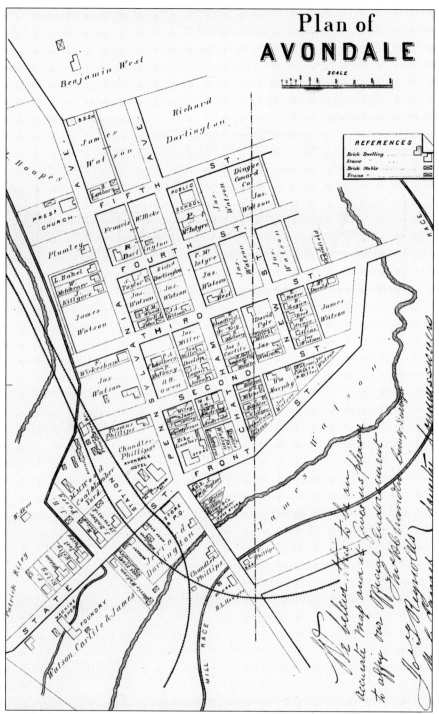

Shown is the plan of Avondale in 1883 from *Breou's Farm Maps of Chester County, Pennsylvania*. (Courtesy of the Chester County Historical Society.)

On the cover: Please see page 32. (Author's collection.)

IMAGES of America
AVONDALE

Bob Cleveland

Copyright © 2008 by Bob Cleveland
ISBN 978-0-7385-5700-7

Published by Arcadia Publishing
Charleston SC, Chicago IL, Portsmouth NH, San Francisco CA

Printed in the United States of America

Library of Congress Catalog Card Number: 2007938821

For all general information contact Arcadia Publishing at:
Telephone 843-853-2070
Fax 843-853-0044
E-mail sales@arcadiapublishing.com
For customer service and orders:
Toll-Free 1-888-313-2665

Visit us on the Internet at www.arcadiapublishing.com

*To my wife, Louise, and to my children,
Kathleen Cleveland Black and Michael R. Cleveland.*

CONTENTS

Acknowledgments 6

Introduction 7

1. Allen, Lamborn, Watson, and Herald Blocks 9

2. State Street 31

3. Schools and Churches 55

4. Pennsylvania Avenue 69

5. Other Streets and Miscellany 113

ACKNOWLEDGMENTS

My sincere appreciation goes to Dominick and Norma DiFilippo, without whom this book would not have been possible. I am deeply grateful to my family—my wife, Louise, and my children, Kate and David Black and Mike Cleveland—for their support. A very special thanks to Pam Powell and Diane Rofini of the Chester County Historical Society for their patience, advice, and guidance. Thank you Bette Cleveland, Kate Black, and Sali Cosford-Parker for the editing of my manuscript. My sincere appreciation to those who provided information and/or photographs for use in this book: the Chester County Historical Society, Edward Brown Jr., Becky Brownback, Tony Crognale, Guido and Jane Fecondo, Russ Kilmer, Teena Peters, William Rhodes, Ralph Rosazza, Tom Rosazza, Phil and Jane Saienni, Mary Sproat, Betsy Eastburn Wilkinson, and Laurie Rofini and Cliff Parker of the Chester County Archives. Thank you R. Scott Steele, John R. Ewing, and Dolores I. Rowe for your dedication to preserving the history of our southern Chester County area. I would also like to acknowledge the contributions made by the late J. Smedley Thomas, Avondale historian, to the preservation of Avondale history both in writing and in photographs.

INTRODUCTION

In the early 1850s, most of what is now Avondale was a large wheat field situated in portions of both New Garden and London Grove Townships. Early Avondale consisted of a stone bridge, four houses, a blacksmith shop, a tailoring shop, a bark mill, and several lime kilns. The village, centered on State Street, was served by the Philadelphia and Baltimore Central Railroad, beginning in 1860, and two mail routes. Led by a number of visionary residents, the village grew rapidly in the late 1860s. Recognizing the opportunities provided by Avondale's rail connection to numerous markets and shipping points, a number of individuals, some of whom are mentioned below, purchased land, constructed buildings, and began operating the businesses that became the foundation for the development of Avondale.

The 320-plus acres that today comprise most of the borough of Avondale were part of a tract of 711 acres of the "Plantation known as Avondale," the Thomas Ellicott farm situated in both New Garden and London Grove Townships. The farm was conveyed to Josiah Phillips in November 1863 by William M. Ellicott as trustee for his six living sisters and also for the spouse of one deceased sister. Ellicott had petitioned the Chester County Orphan's Court in September 1863 for the sale, stating that all parties concerned agreed to sell and convey the property to Phillips. Later in 1863, Phillips sold the majority of the land to Benjamin F. Wickersham. Wickersham sold several parcels and then later sold the remainder of the land in May 1865 to John Yerkes and Chandler Hall. Later that year, Hall sold his interest in the land to George S. Jones. Yerkes and Jones began selling the land to various purchasers. These sales continued until the late 1870s, when Jones's estate sold the remainder of the land.

James Watson's combined purchases of 97 acres constitute much of the present-day Avondale. He purchased the Avondale Hotel property of two acres, which now contains the bank building, the post office, Earl's Sub Shop, a stone building built in 1775 (presently occupied by Worldwide Travel), and two private residences. On another purchase of 11 acres, he, John Carlile, and John James erected an iron foundry and machine shop and a lumber and planing mill. Using the remaining acreage of his purchases, he devised a "Plot of Lots of Avondale" on which he designated "Front Lots, Back Lots, and Third Tier Lots." Watson sold the lots, some of which contained homes that he had constructed himself using doors, sashes, moldings, and windows, made at his mill located on the Avondale Iron Foundry and Machine Works property on State Street.

Ziba Lamborn anticipated the coming growth of the then village of Avondale by purchasing an acre of land on which he erected a two-story brick building called the Lamborn Block, a block being a large building divided into separate functional units, to be used for his general

store and an additional store; he also built his home on a portion of the land. Avondale Hall was located on the second floor of his building and used by the community for fraternal, social, and religious events.

Howard Hoopes purchased 26 acres located on the west side of Pennsylvania Avenue from just below where it intersects with Fourth Street and north to the present London Grove Township line. His subsequent land sales included the site where the Avondale Presbyterian Church is erected, several residences, and a portion of the property owned by the Borough of Avondale.

Samuel Morris purchased land located on the west side of the Gap-Newport Turnpike (Pennsylvania Avenue) from William Ellicott in 1863 and built a two-story stone warehouse. The second floor was designed to be used as a hall for community events. The warehouse was home to many businesses over the years, including the tin shop of Richard B. Chambers, the furniture warehouse and undertaking establishment of William Hopper, the Avondale Ice and Cold Storage Company, and the Turner and Pusey Abattoir. After the building was razed, the land became the site of Raymond Rosazza's Garage; it is now the site where Maximum Fitness and a service station are located. William Stinson's purchase of two parcels of land, one containing two acres and one containing an acre, eventually led to Pusey's Hardware, Thomas' Plumbing, Avon News, and the Lipp Building, later occupied by Frank Ponte.

Joel B. Pusey and Joseph Barnard purchased the "Bark Mill Tract" parcel containing a steam sawmill, barns, and two tenements. This property became the area on which Menander Wood's lumber and coal yard; a frame, and later stone, flour and feed mill; and the Avondale Lecture Hall were located. Today the area is the site of Edlon.

Purchases by Samuel Bacon, George Tucker, William Brown, Moses Rhoades, and Isaiah Watson of small parcels of three to five acres of land from Cornelius O'Connell between 1869 and 1871 helped form the basis for Avondale's African American community on the west side of Church Street and the north side of East Third Street. Henry Lewis purchased a 17-acre farm from John Thomas, which became the basis for the east side of Church Street and, additionally, Henson, Maple, Thompson, Poplar, and Spruce Streets. Lewis also sold a parcel from his land to the trustees of the African Methodist Episcopal Zion Connection, upon which they erected a church that became the second location for Mount Tabor African Methodist Episcopal Zion Church. Later that church was to become the home of Galilee Union American Methodist Episcopal (UAME) Church. The Reverend John Hood, a pastor at Galilee UAME Church, was one of the original five members of the council when Avondale was incorporated as a borough in 1894.

The churches constructed in the 1870s, Avondale United Methodist, Mount Tabor African Methodist Episcopal Zion Church, Avondale Presbyterian, and Galilee UAME, continue to contribute to the spiritual growth of Avondale and the surrounding communities. Also in the 1870s, the Religious Society of Friends met in Avondale Hall in the Lamborn Block, and a group of quarry workers from the Pennsylvania Marble and Granite Company in London Grove Township established the New Mennonites and met in Samuel Morris's hall on Pennsylvania Avenue.

Much gratitude is also owed to those many unnamed individuals who, throughout the years, shared a collective purpose by envisioning, planning, problem solving, listening, and making decisions that helped mold Avondale into a community. Avondale is about all those individuals who anticipated and responded to the needs or preferences of others and took the risks involved in order to make Avondale a living, viable community.

The first known inhabitants of the Avondale area, the Native Americans, the Lenni-Lenape, or as the name means, "the true people," held the belief that all things are connected and essentially that there is a bridge that connects the past with the present. Each one of us feels that connection. The very fact that you are holding this book in your hands validates that statement. It has also been said that, "history is a journey, not a destination." I invite you now to journey with me through a small portion of the history of Avondale.

One

ALLEN, LAMBORN, WATSON, AND HERALD BLOCKS

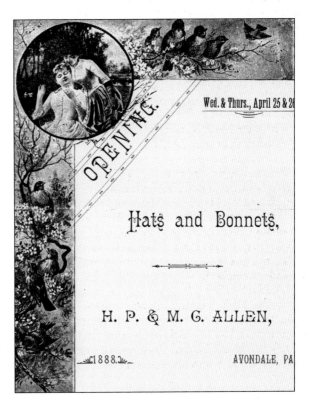

Hannah P. and Mary C. Allen established a millinery store in Avondale in 1880. In late 1884, they moved their business to the newly built Allen Block, located on the northwest corner of Pennsylvania Avenue and Third Street, constructed by their brother Davis Allen. The trade card pictured announces the Allen sisters' 1888 opening.

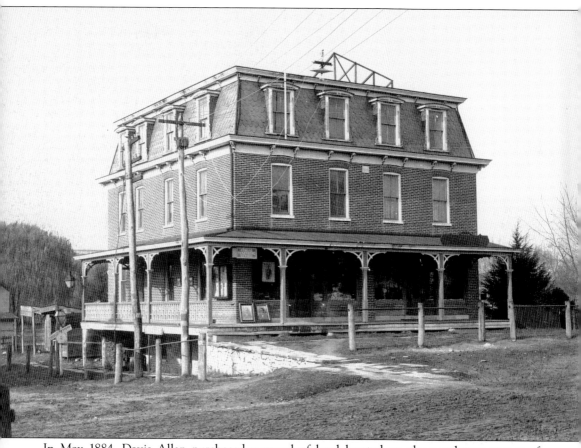

In May 1884, Davis Allen purchased a parcel of land located on the northwest corner of Pennsylvania Avenue and Third Street from James Watson for $550. In July of that year, construction began on the Allen Block. The first floor contained two stores; one store was to be used as a millinery store for his sisters, Hannah and Mary Allen, and the other store was to be rented. The second floor was to be used as a dwelling, and the third floor was designed as a meeting hall for the Avondale Light of the Valley Lodge No. 1196, Independent Order of Good Templars, and also as a meeting place for other organizations. The Building Association of London Grove, the London Grove Grange, and the Patriotic Order of Sons of America Lodge each met here. Over the years, the basement area was utilized by a number of bakery businesses. In December 1923, the heirs of Davis sold the building to John D. Miller. The building is presently a residence.

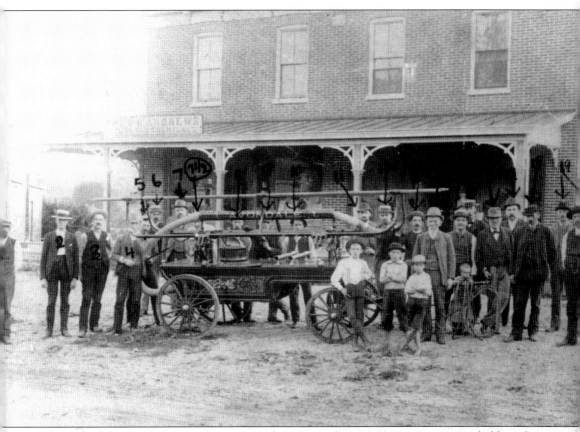

The Avondale Fire Company was organized on December 14, 1887, at a meeting held in the office of R. F. Meloney at the Philadelphia and Baltimore Central Railroad station. At this meeting, a committee was appointed to draft a constitution and bylaws. Another committee was appointed on January 19, 1888, to "proceed in negotiating for a fire apparatus" as stated in their minutes. The engine was ordered in March 1888 from Gleason and Baily Company for $804. The fire company began meeting in the Allen Block, on the northwest corner of Pennsylvania Avenue and Third Street in March 1888. Rent was $12 per month and included light and heat. The company accepted an offer from Joel B. Pusey in April 1888 to house the fire engine in a portion of his stable on State Street for $1 per month. In November 1889, a fire bell was procured and installed in the windmill tower belonging to Warren Shelmire located on State Street. The above photograph, taken in 1888, depicts the fire company members in front of the Allen Block.

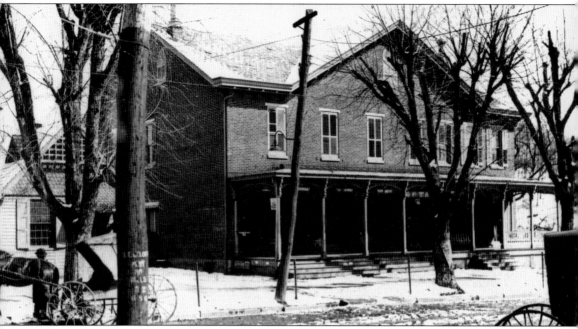

"We will have open and for sale on and after Monday morning, a full line of goods usually kept in a country store" was what Ziba Lamborn's advertisement stated in the *Kennett Advance* announcing the opening of his store on the northeast corner of Pennsylvania Avenue and Front (now First) Street on April 1, 1869. Lamborn had purchased an acre of land of the former Avondale Farm on June 26, 1866, from John Yerkes and George S. Jones, and soon after, construction began on a brick building to be used as his general store. The second floor of the building, termed Avondale Hall, was to be used as a hall for public meetings and social activities. The Avondale Post Office was located in this building from 1898 until 1941.

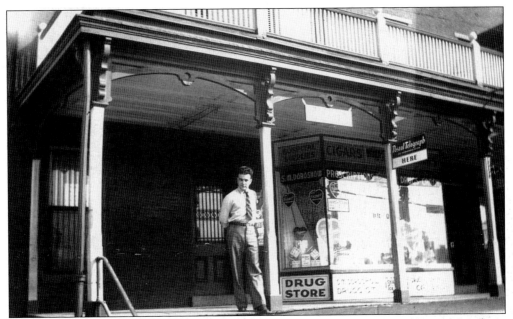

In May 1940, Sidney M. Doroshow of Chester purchased the drugstore located in the Lamborn Block on the northeast corner of Pennsylvania Avenue and First Street from H. Abner Jones. The purchase also involved a long-term lease on the building. Doroshow operated the store until 1949, when he retired and moved to Florida. The north end of the Lamborn Block was home to the Avondale Post Office under four postmasters for 43 years until 1941. The photograph above pictures former assistant postmaster J. Jackson Woods in the 1940s; the photograph below pictures from left to right, Sidney Doroshow, Charles Nigro Sr., and an unidentified young man at the soda fountain in Doroshow's Drug Store in 1944.

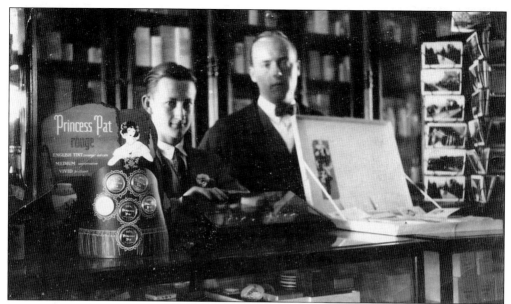

In 1914, Thomas C. Marshall purchased the stock and fixtures of both the Chambers and Megilligan drugstores and opened his store in the Lamborn Block. Marshall's was to be the first of five drugstores that operated in the Lamborn Block. Succeeding him were William Ely, H. Abner Jones, Sidney Doroshow, and Ross Ritter. This photograph depicts the interior of Ely's drugstore in 1926 with clerks Mark Jenkins (left) and Ralph Richardson.

In October 1913, Dr. Cary Lee Lamborn of Philadelphia, son of Ziba Lamborn, sold the Lamborn Block to Charles Y. Wilson, owner of the Avondale Hotel. Lamborn and his brother, Cecil B. Lamborn, had acquired the property by bequest in the will of their mother, Henrietta Baker Lamborn. This photograph is a view looking west on State Street in 1932 from the porch of the Lamborn Block.

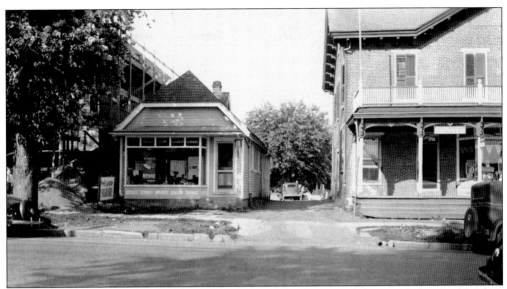

The Italian Beneficial Association of Sant'Antonio di Padova (St. Anthony of Padua) met for social gatherings in this small store when it was the shoe repair shop of Frank Ponte and Company in 1911. The association's officers were Paul Vanore, Giustino Ficcio, Frank Ponte, and Antonio Torello. In 1936, the building was the appliance store of William Lamborn. The construction of the new borough municipal building can be seen in the left of the picture.

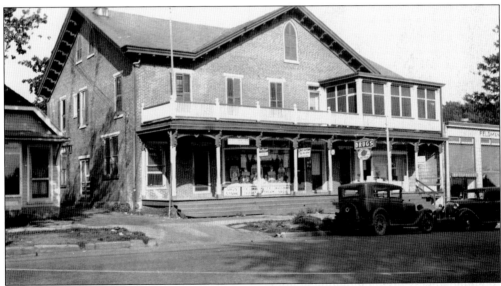

When constructed in 1869, the Lamborn Block's second floor was called Avondale Hall and used for community events. The Avondale Indulged Meeting of the Religious Society of Friends met in the hall from 1874 to 1879, and lecture courses began in the hall in 1874. The Lamborn Block is pictured here in 1936 when it was occupied by the post office, H. Abner Jones' Drug Store, and Feldman's Department Store.

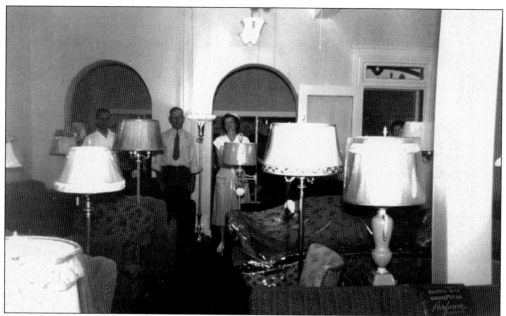

D. Frank Keener founded the D. F. Keener and Son furniture store in the living room of his home in Chatham in 1946. In 1948, needing more space, Keener moved his business to a store located in the Lamborn Block on Pennsylvania Avenue and remained there until 1951 when he moved to a larger facility in London Grove Township. The photograph depicts the interior of the store during the grand opening in June 1948.

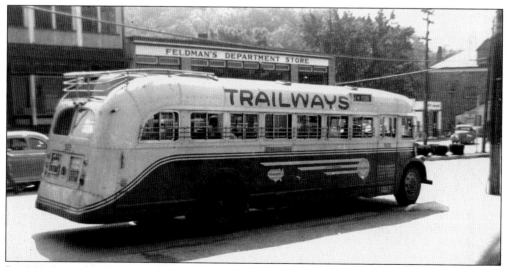

In 1928, Samuel Feldman purchased the Lamborn Block from Charles Y. Wilson. The following year, Feldman added a large addition to the south side of the building, which was to become known as Feldman's Department Store, seen in this 1943 photograph. Later it was known as the Avon Department Store. Both the Trailways and Short Line Bus stations were also located in the Lamborn Block in 1943.

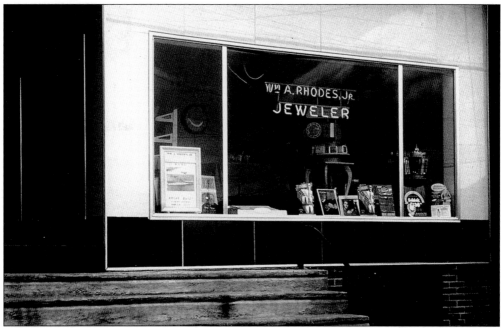

Norman S. Pusey purchased the Lamborn Block from Samuel Feldman in February 1948. At that time, the building contained four stores and five apartments. George Collett of Wilkes Barre assumed ownership of the Avon Department Store in September 1949, and in 1950, Ritter's Pharmacy held its grand opening. William A. Rhodes Jr. established his jewelry store in Collett's Department Store on February 1, 1950. In July 1954, Elias Silverstein purchased the Lamborn Block. At that time, the property contained four businesses: Ritter's Pharmacy, Interstate Electric Store, Collett's Avon Department Store, and Rhodes's jewelers. The photograph above depicts William A. Rhodes's Jewelry Store in 1954, and the photograph below is a view of the Lamborn Block in 1955.

The first of three structures to bear the name Watson Block was built in November 1893 by J. Morris Watson on the east side of Pennsylvania Avenue between Front Street (now First Street) and the White Clay Creek, in an area known as Mechanic's Row and also known as the "Wharf." The building housed Watson's Meat Market and Harry Miller's grocery store on the first floor and Watson's Hall, several small meeting rooms, and the club room of the Bachelor's Club on the second floor. The Avondale Lecture Course, sponsored by the Bachelor's Club, began in the upstairs hall in 1894. On Christmas Day 1896, a fire destroyed the Watson Block and two adjacent buildings, including one owned by the Bernard Gause Post No. 34 GAR. In 1897, the second Watson Block was to be built. This 1896 photograph depicts Pennsylvania Avenue looking south from near the Avondale Hotel. State Street is the road to the right in the photograph. The Watson Block is the second building at the left of the photograph.

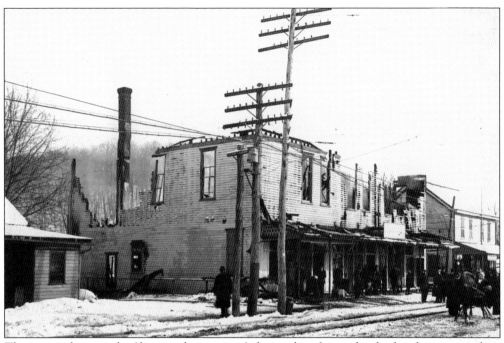

These two photographs (front and rear views) depict the aftermath of a fire that occurred on January 30, 1910, and destroyed the second Watson Block, which had been built in 1897 to replace the previously burned frame structure. At the time of the second fire, the building was occupied by the W. P. Watson and Company meat store, the *Avondale Herald* office and printing facility, George Anderson's gramophone and sheet music store, Watson and Anderson's moving pictures company, Watson's Hall, and the room occupied by the Avondale Dancing Academy. After the fire, W. P. Watson and Company moved into temporary quarters in the former Bachelor's Club Building on State Street.

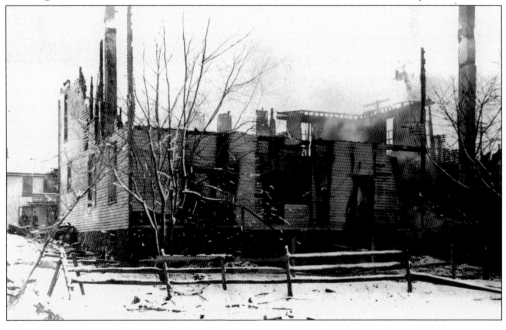

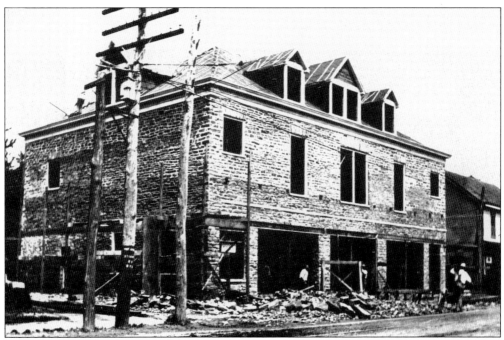

After the fire that had destroyed the second Watson Block on January 30, 1910, a third building was erected of stone late in that same year. The new building had its grand opening on October 26, 1910, with entertainment under the auspices of the New Garden Auxiliary for the benefit of the Chester County Hospital. By December 1910, both the W. P. Watson and Company and the *Avondale Herald* office had moved back into the building at their previous locations on the first floor. During the construction of the new building, the *Avondale Herald* had a temporary office in the Allen Block, and the newspaper was being printed at the *West Grove Independent* office in West Grove. The photograph above is the building during construction in April 1910, and the photograph below is the building in November 1910.

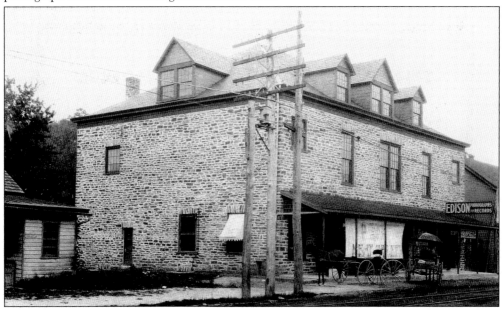

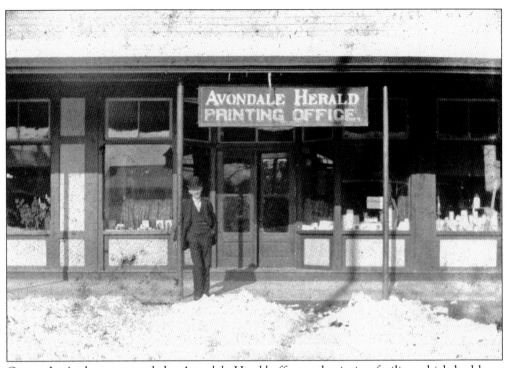

George L. Anderson moved the *Avondale Herald* office and printing facility, which had been formerly located on the south side of State Street, to the Watson Block in October 1899. In a notice in the *Avondale Herald* on October 27, 1899, Anderson thanked Caleb Cooper and Henry R. Pusey for the use of their horse and wagon in helping him move to the new location. In the photograph above, Anderson is pictured in front of his office in the Watson Block in early 1906. The image below shows an admission ticket from 1905 for one of the many events held in Watson's Hall, located on the second floor of the Watson Block.

ADMISSION TICKET

PROGRESSIVE EUCHRE,

FOR THE BENEFIT OF

WEST GROVE CATHOLIC CHURCH

WATSON HALL, AVONDALE, PA.,

FRIDAY EVE., APRIL 28, 05,

COMMENCING AT EIGHT O'CLOCK.

PRICE FIFTY CENTS.

In early 1909, George L. Anderson, the editor and proprietor of the *Avondale Herald*, expanded his music store, which had been in a portion of the *Avondale Herald* office, to an adjacent store also located in the Watson Block. Anderson offered Victrolas, Victor records, sheet music, and songbooks. The interior of the music store with its phonograph record listening booth is pictured here in early January 1910.

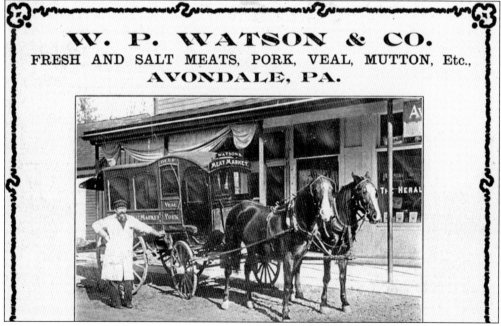

J. Morris Watson established Watson's Meat Market in the 1870s on the south side of State Street near the Philadelphia and Baltimore Central Railroad tracks. In 1893, he moved his meat store and butchering business to the recently erected Watson Block located on the east side of Pennsylvania Avenue next to the blacksmith shop. Pictured above is Watson's delivery wagon in front of the Watson Block in 1906.

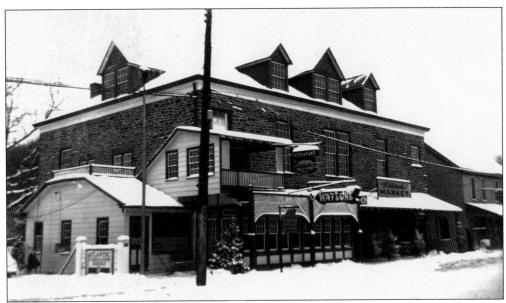

In September 1939, Modesta W. Morris purchased from Eva W. Watson the Watson Block and Watson's Coffee Shop located on the east side of Pennsylvania Avenue between First Street and the White Clay Creek. Morris had been employed by the Watson family for a number of years and had managed the business when the Watson family was out of town. The grocery business located in the same building, formerly owned by Wilmer P. Watson, had been purchased in early 1939 by her husband, Frank Morris, who had managed the grocery store for a number of years prior to the purchase. These two photographs depict the Watson Block after the Morris' purchases. The photograph above is from 1944, and the photograph below is a view in 1940.

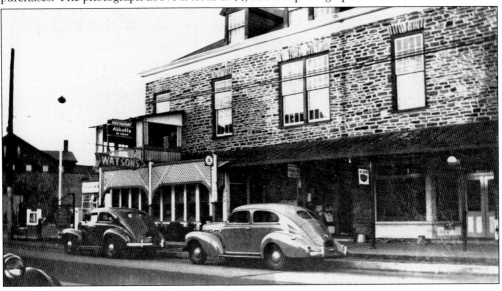

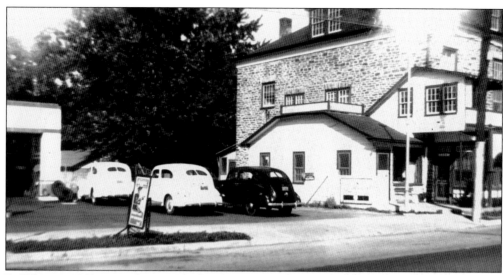

In February 1962, an early-morning fire destroyed the third Watson Block. The fire destroyed Watson's Market, owned by Bob Armstrong, and the two apartments above the market. Six fire companies responded; the damage to the building was estimated at $100,000. The Watson Block would never again be rebuilt. The building had also been used as the Avondale state police substation and barracks until 1954. A portion of the Watson Block with the attached state police facility is pictured here in the above photograph in 1941. The photograph below is a 1913 view of the Watson Block and J. Quarll Mackey's Drug Store at the right of the photograph.

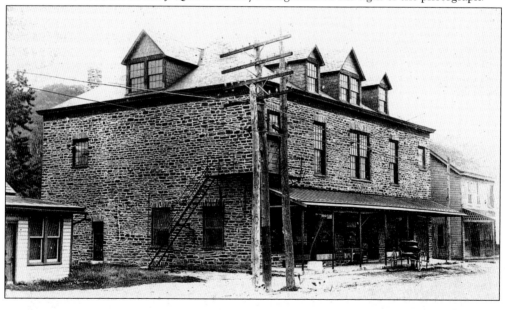

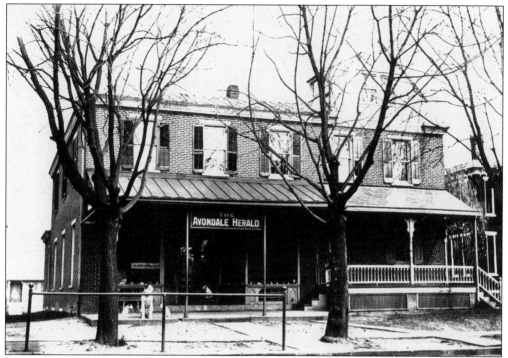

The building that was to become known as the Herald Block, located on the southeast corner of Pennsylvania Avenue and Third Street, was built in 1891 for Brinton H. Chambers for use as his store and residence by builder Henry C. White for $5,371. Chambers, who had established a drugstore and general store in Avondale in 1869, moved his store here in 1892, having previously been located on the east side of Pennsylvania Avenue in Mechanic's Row, just below First Street. The photograph above shows the Herald Block in 1918; the photograph below depicts employee Ray Jenkins with George Anderson's delivery truck in 1920.

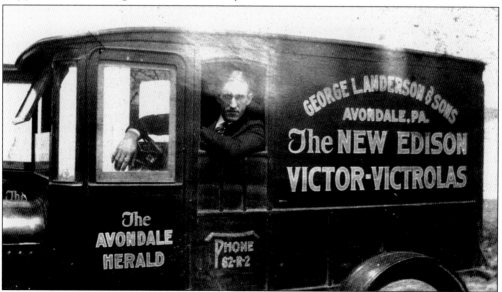

Brinton H. Chambers, who had been postmaster in Avondale from August 9, 1869, until March 5, 1883, when his store was located on the south side of State Street in the building later occupied by Joshua Thomas's Tin Shop, purchased a lot located on the southeast corner of Pennsylvania Avenue and Third Street from Robert Bell on December 29, 1877, and erected a building in 1891. Chambers and his brother Richard B. Chambers had also operated a business known as Chambers Brothers located in the stone hall on South Pennsylvania Avenue near where Maximum Fitness is now located. The photograph above shows the front of Chambers's store, with Sarah O. Chambers and Sarah Mitchell in 1914. The photograph below shows the new delivery wagon for the *Avondale Herald*.

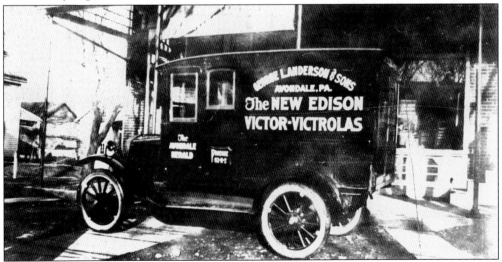

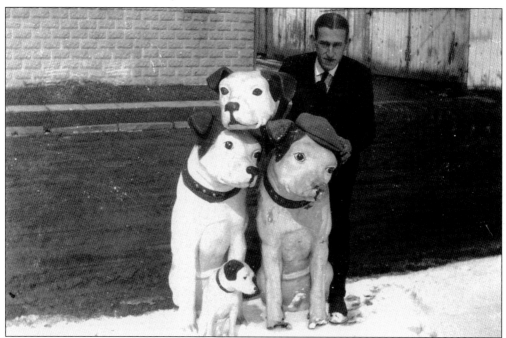

In April 1917, George L. Anderson purchased this building from Sarah O. Chambers and moved the *Avondale Herald* newspaper to this location. In addition to publishing the *Avondale Herald* and operating the Herald Electric Print, a job-printing business, Anderson was the distributor for and sold Edison Victor-Victrolas at the *Avondale Herald* office. Anderson sold the *Avondale Herald* in 1922 and became advertising manager of the *Daily Local News* in West Chester. Pictured above is Ray Jenkins at the rear of the building on Third Street with Edison mascot Nipper in 1920. In the photograph below Jim Rosazza and Ray Jenkins, employees of the *Avondale Herald*, stand in front of the Herald Building in 1921.

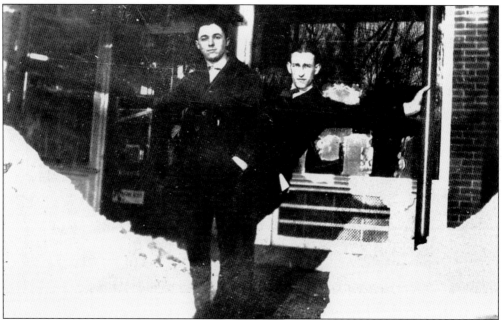

Harry L. Eastburn established his funeral home in Avondale in the Allen Block in 1917, after purchasing the goods and funeral equipment of William A. Clarke for $300. In 1927, the funeral home moved to the Herald Block, on the southeast corner of Pennsylvania Avenue and Third Street, after Eastburn purchased the building from George L. Anderson. Eastburn and his wife, Clara M. Greenfield Eastburn, who was the first woman licensed to practice funeral directing in Chester County, operated the business until his death in 1954. That year, L. Scott Eastburn purchased the firm. The Eastburn family served Avondale and the surrounding communities for almost 60 years. The photograph above shows the building in 1937 and the photograph below in 1955.

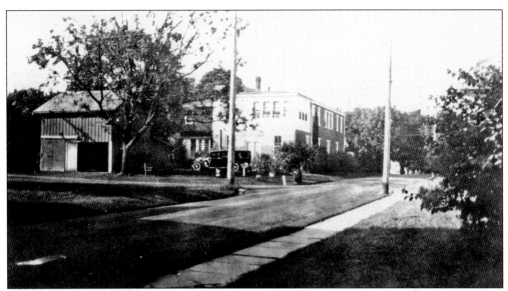

On February 16, 1926, Harry purchased the Herald Block from George and Lillie Anderson for use as his funeral home. In the agreement between the parties was a lease to John W. Jones on the north side of the first floor of the property. Jones had purchased the *Avondale Herald* from Anderson in July 1922. In February 1929, the Avondale Library moved to the north side of this building and operated there until 1934. The building has served the community as a funeral home for 80 years. The above photograph pictures the rear of the funeral home looking west toward Pennsylvania Avenue in 1928. The photograph below depicts Eastburn's motor hearse, also in 1928.

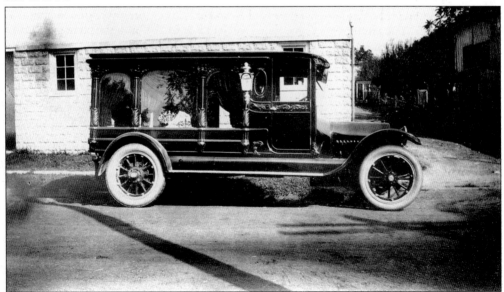

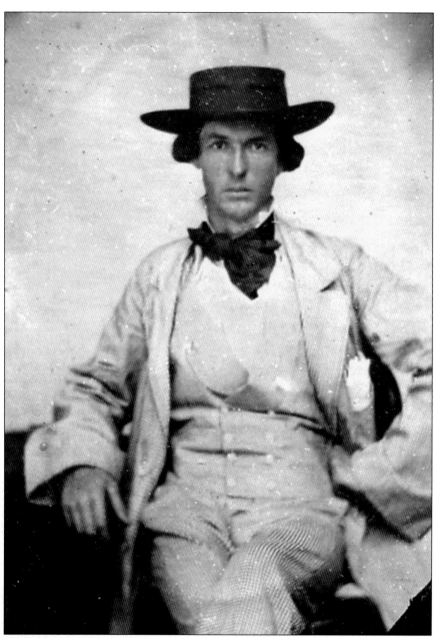

Taylor Thompson, a master cabinetmaker and undertaker, practiced in Avondale and New Garden Township beginning in 1856. In 1885, Thompson moved his practice to the northwest corner of First and Chatham Streets. In 1904, he sold his practice to Warrington F. Guthrie of Chesapeake City, Maryland. Bayard T. Fisher, in addition to operating the livery stables on State Street for a time, began practicing funeral service in 1906. At his death in 1917, he was succeeded by William Clarke, who, in 1918, sold his practice and that of Fisher to Harry L. Eastburn. Eastburn's widow, Clara, sold the business to their nephew L. Scott Eastburn in 1954. The practice was sold to Robert W. Cleveland Jr. in December 1977 by Ellen G. Eastburn. Today funeral service in Avondale and the surrounding communities continues under the direction of the Cleveland and Grieco Funeral Home. This ambrotype depicts Thompson in the late 1850s.

Two
STATE STREET

Harry J. Miller purchased the former National Bank of Avondale building from Robert L. Pyle on April 2, 1897. Miller operated a restaurant as well as a grocery business in the building for a number of years; in June 1912, he sold the building to William C. Blittersdorf for $4,500. The building was once part of the two-acre Avondale Hotel property.

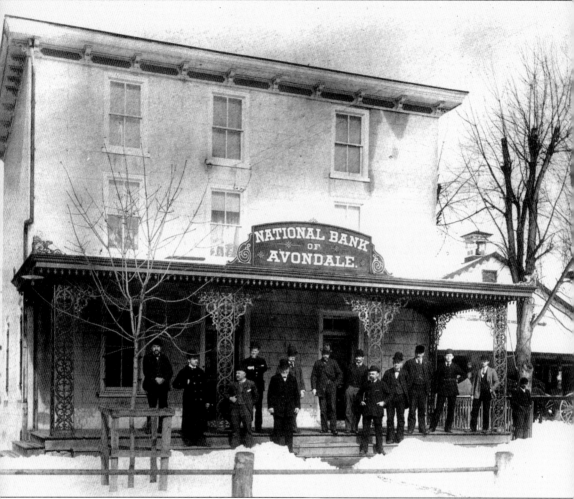

Two days prior to receiving the bank's charter, the directors of the National Bank of Avondale made the decision to rent, for the sum of $175 a year, property owned by Robert L. Pyle located on the north side of State Street at the Pomeroy Railroad in the structure known as the Bachelor's Club Building. That same day, Davis Allen had offered the use of the Allen Block on Pennsylvania Avenue. On June 25, 1891, the bank opened for business and received over $19,000 in deposits on its first day. The directors of the bank pictured are, from left to right, R. Frank Meloney, E. Pusey Passmore, William J. Pusey, Mahlon G. Brosius, Samuel Sharpless, Thomas H. Marvel, William Marvel, Harry C. Taylor, Samuel Wickersham, Augustus Brosius, I. Frank Chandler, Charles T. Richards, Edward Pusey, and Rufus I. Foster (maintenance).

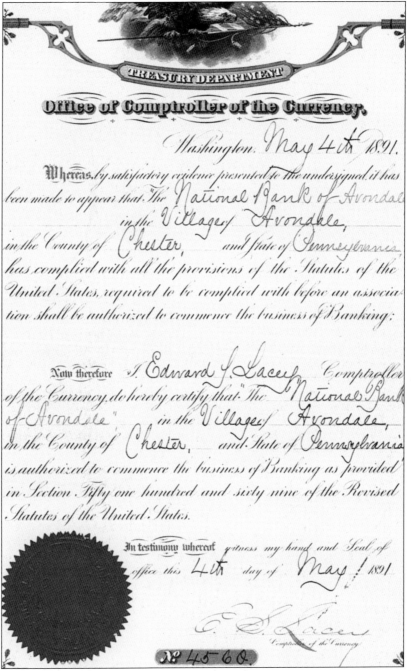

The National Bank of Avondale was organized on April 11, 1891, at a meeting held in the Allen Block on Pennsylvania Avenue. Samuel Wickersham was chosen as president, and, at a subsequent meeting, E. Pusey Passmore was chosen as cashier. On May 4, 1891, the bank received its charter from the comptroller of the currency, and William J. Pusey was directed to advertise in the *West Grove Independent* that the bank was authorized to commence business. The first bank dividend of 2½ percent was paid in December 1894, and in January 1901, the bank increased its dividend to 6 percent. A photograph of the original bank charter is pictured.

Beginning in the 1850s and continuing into the early to mid-1920s, the center of business activity in Avondale was located on State Street. Starting with a general store and post office and a blacksmith and harness shop, the area was transformed by the coming of the railroad in 1860. After that, the Avondale Iron Foundry and Machine Works; National Bank of Avondale; two post office locations; greenhouses; several meat, grocery, and food markets; barbershops; notion and trimming stores; restaurants; bakeries; tinsmiths; tailors; jewelers; and shoemakers all established their businesses on State Street. The two photographs, looking west onto State Street, where taken from the corner of the Lamborn Block property; the photograph above in 1921 and the photograph below in 1930. Note the H. R. Pusey building of frame construction in the photograph above and of stone in the photograph below.

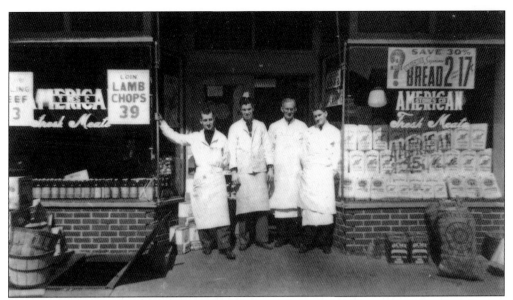

In November 1929, the Chain Stores and Property Investment Company built what the tax records term "a tile building" on the north side of State Street on a portion of the former Avondale Hotel property. The American Stores Company moved into the building in 1930. Earl D. Saienni purchased the building in 1959 and moved Earl's Sub Shop, which had previously been located on the north side of East Third Street next to the former parsonage of the Galilee UAME Church. Saienni, and later his sons, operated the business for 37 years, until it was sold in 1992. The photograph above, taken in the 1940s, shows the building when it was occupied by the American Stores Company. The photograph below depicts Earl's Sub Shop in 1960.

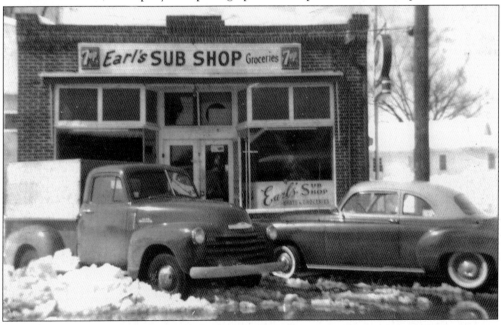

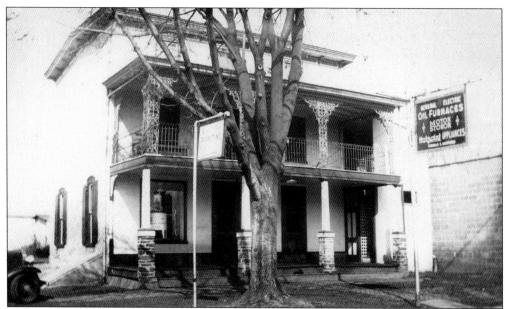

Erected in 1775, this building, located on the northeast corner of State Street and Pomeroy Avenue, and formerly part of a two-acre parcel known as the Hotel Property, was purchased by James Watson from Aaron Baker in March 1866. The National Bank of Avondale was established here in 1891. Over the years, the building has served the Avondale community in many capacities. In the late 1920s, Samuel Wharry established his Sanitary Meat Market here, and C. Lawrence Martin, in 1939, established the Avondale Press, a job printing business. The above photograph depicts the building when Thomas C. Medford was operating an appliance store and Martin ran the previously mentioned job printing business. Martin leased the rear of the building on August 1, 1939, for $20 per month. The photograph below shows Martin operating his press in 1941.

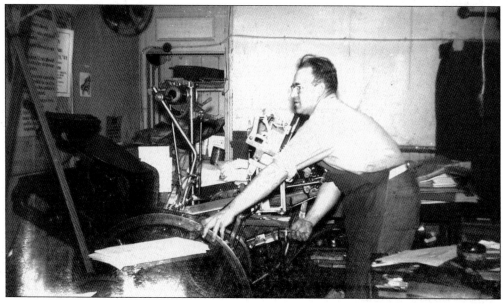

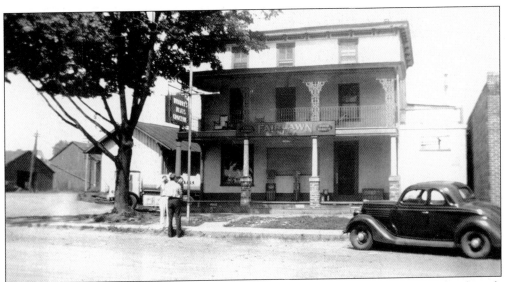

In February 1814, Jonas Pusey advertised in the *American Republican* newspaper that his tilt hammer forge, located in a "large smith shop of stone," was for rent. This advertisement is the earliest record found pertaining to the building that was later to become known as the Bachelor's Club Building, located on the north side of State Street adjacent to the Pomeroy and Newark Railroad. In August 1926, Samuel Wharry, who had previously managed the Avondale American Store and was later to become the burgess (now mayor) of Avondale, established his Sanitary Meat Market in the building. Wharry and his wife, Reba Blittersdorf Wharry, purchased the building in August 1932 from his father-in-law, William C. Blittersdorf. The 1936 photograph above is Wharry's Fairlawn Food Market, and the photograph below shows Martin Jenkins loading Wharry's delivery truck in the early 1930s.

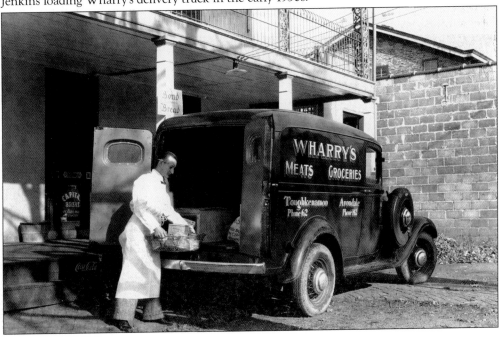

Joshua Thomas purchased the building that was located on the south side of State Street across from the present-day Earl's Sub Shop from Robert L. Pyle in March 1899 for $4,400. The purchase also included several barns and an additional parcel of land. Thomas operated a tinsmith and plumbing shop here for many years. Built prior to 1850, the building was home to the Avondale Post Office from March 18, 1852, until January 1886. Prior to the building of the Avondale Hotel, it was the location of the Avondale to Wilmington stagecoach office. Rebecca F. J. Brown, in addition to being postmaster, operated a general store and drugstore here from 1851 until 1858. The photograph above is a view of the building in 1935, and the photograph below was taken in 1947.

Located on the south side of State Street next to the Philadelphia and Baltimore Central Railroad, this building was built in 1877 by Henry Pratt in anticipation of its use as the new Avondale Post Office but politics intervened, and instead it was rented to J. Morris Watson and used as Watson's Meat Market. In March 1899, William C. Blittersdorf, a barber, purchased the property from Robert L. Pyle. Located on the property at the time of the purchase were a shop and a large frame stable, which was being operated as a livery business by George Timanus. Mrs. William Blittersdorf operated the Avon Tea Room here for a number of years. The building is shown above in 1942, and below William T. Blittersdorf is shown at work in his barbershop in 1944.

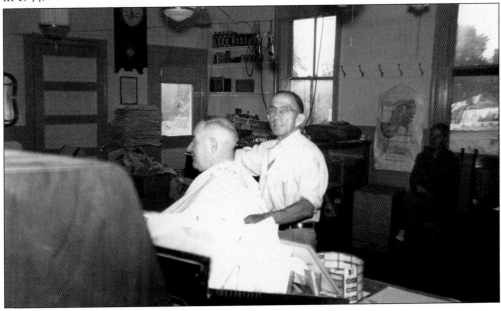

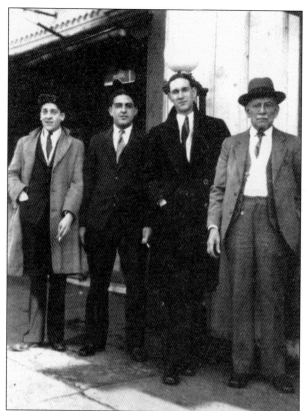

In 1884, having succeeded Asa Sandelin, William C. Blittersdorf was operating his barbering business in Avondale on the north side of State Street approximately where Earl's Sub Shop is now located. In 1891, Blittersdorf moved his business to the south side of State Street where Avon News is now located. Pictured in front of Blittersdorf's shop in 1934 are, from left to right, John Vanore, Albert LaFrance, Herbert Cleveland, and Blittersdorf.

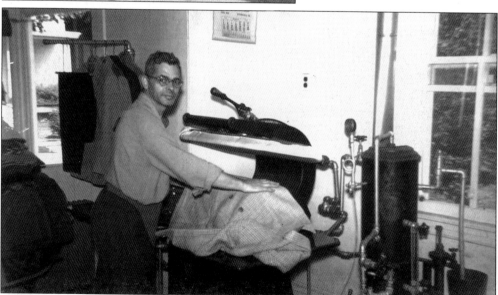

Joseph Fecondo opened his tailoring establishment in Avondale in 1919 in a store located in the GAR building on Pennsylvania Avenue. Fecondo was a tailor for over 70 years and at the time of his death in 1982, had practiced his trade in Avondale for 63 years. In April 1926, Fecondo and his wife, Maria, purchased the J. Morris Watson home on State Street. This 1939 photograph pictures Fecondo in his shop on State Street.

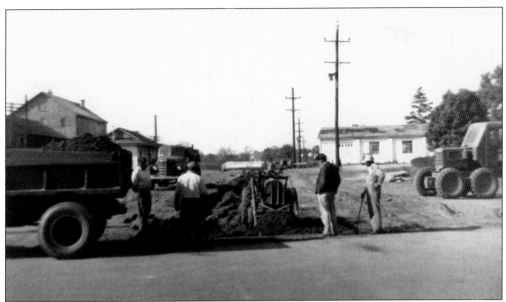

On January 4, 1949, under Ordinance 2A, the Avondale Borough Council ordained, completed the construction of, and opened for public use Pomeroy Avenue, which ran parallel to and between Pennsylvania Avenue and the Pennsylvania Railroad from State Street to Third Street. Pomeroy Avenue was the only new street, to that date, to have been opened in the borough since 1894. Pomeroy was named because it follows the tracks of the Newark and Pomeroy Railroad, which were removed in 1944. Sometime after the removal, the former railroad station was moved from the east side to the west side of Pomeroy Avenue. The photograph above shows the construction of Pomeroy Avenue in 1948. The photograph below depicts the former Pomeroy Station in 1944, when it was the property of the Chester-Delaware Farm Bureau Co-Operative Association.

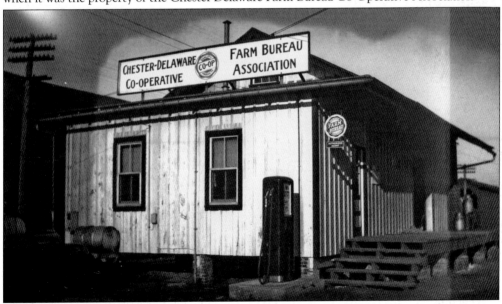

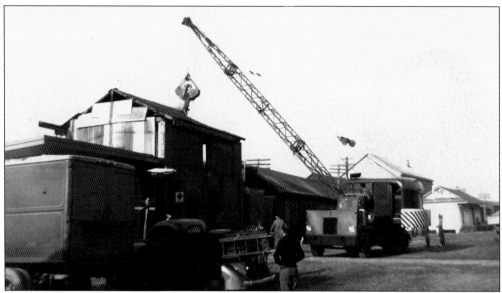

A ceremony for the groundbreaking of the Philadelphia and Baltimore Central Railroad was held on Wednesday, January 3, 1855, in Concord Township, Delaware County. In late 1860, the railroad reached Avondale, the estate of Thomas Ellicott, at that time the railroad's terminus. Prior to the trains reaching Avondale, there were daily stage connections from Chatham via Avondale and Kennett Square that connected with the train at Chadds Ford. In July 1860, a newspaper noted that the railroad had commenced building "a substantial two story house at Avondale for the accommodations of passengers instead of the temporary structure now used." By September 1860, that railroad station had been built, and three trains were running daily in both directions. The two photographs depict the demolition of that two-story railroad station in November and December 1945.

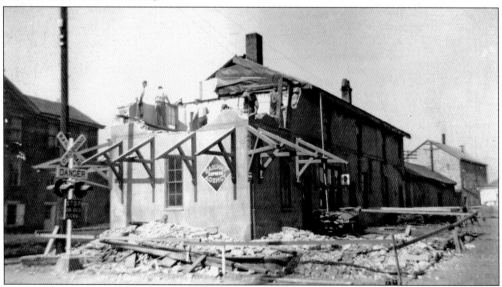

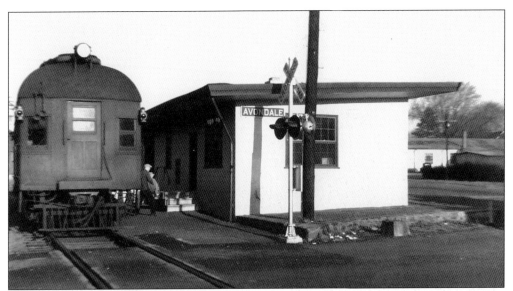

Samuel D. Forbes, operator of the general store on State Street and Avondale postmaster from 1859 until 1862, became the first agent for the Philadelphia and Baltimore Central Railroad. In June 1860, he had completed building a grain warehouse and siding that were to be used as a general freight station for the railroad. Pictured above is the Avondale railroad station newly built in 1946 to replace the old 1870s structure.

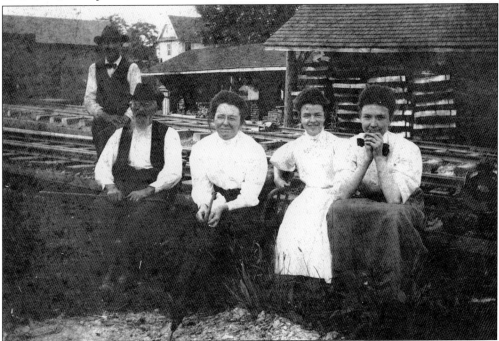

William J. Eakin, who had purchased land on the north side of State Street from Patrick Riley in 1873, was in charge of the signal house in Avondale at the junction of the Philadelphia and Baltimore Central and the Pomeroy and Newark Railroads from 1886 until 1908. Pictured in 1908 at the switch where the two railroads met are, from left to right, John Anderson, William J. Eakin, Jennie Eakin, Sue Hannum, and Ann Hannum.

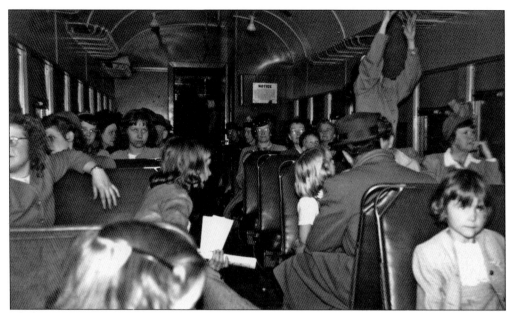

The Pennsylvania Railroad made the decision in late 1947 to discontinue passenger service on the Octorara Branch of the railroad. Bus service, the availability of automobiles, and plunging revenues had taken their toll on the railroad. The last passenger train between Avondale and Oxford via West Grove left Avondale station on the evening of April 30, 1948, and arrived in Oxford with 96 passengers aboard. The passengers on the last train are shown in this photograph.

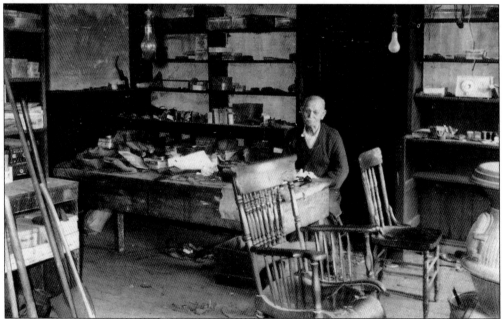

Frank Ponte opened his shoemaker's shop in Avondale about 1908 in the small building adjacent to the Lamborn Block on Pennsylvania Avenue. Later his wife, Angela Ponte, purchased the Lipp Building, located on the north side of State Street, in 1920. Frank was a shoemaker in Avondale for about 60 years prior to his death in 1967. This photograph pictures Frank in his shop in the former Lipp Building in the late 1950s.

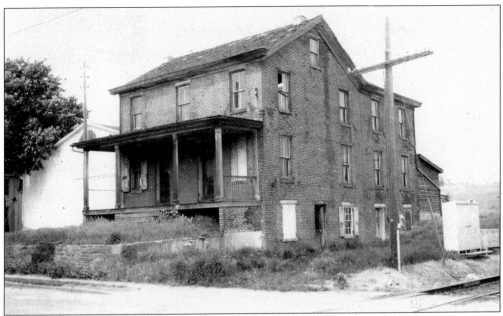

The Lipp Building, which was located on the north side of State Street next to the Philadelphia and Baltimore Central Railroad, was built in 1868 by J. Baker Steward, a bricklayer and the pastor of the Avondale Methodist Episcopal Church, who had purchased the acre property in February of that same year. Lewis Lipp established his bakery, confectionery, and home here in late 1875. In March 1884, Lipp purchased the building. Later Lipp became justice of the peace for Avondale and conducted business here for many years. Over the years, the building was used by several bakers and also as a restaurant. The photograph above pictures the building in the 1960s prior to its demolition. The 1942 photograph below is a view of the Lipp Building and State Street from both railroad bridges.

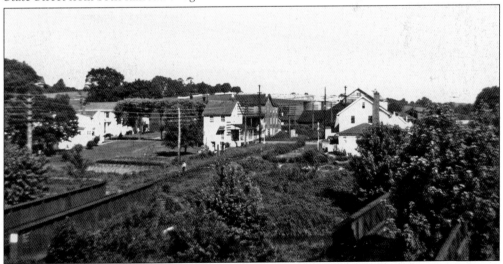

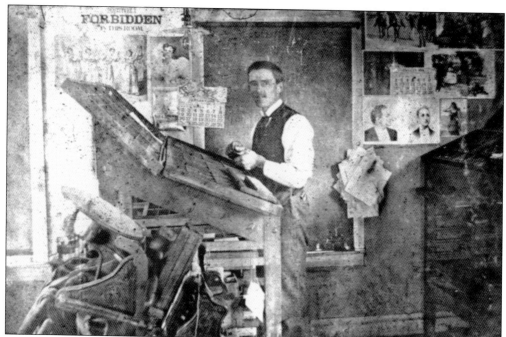

George L. Anderson became manager of the *Avondale Herald* in 1896, when Charles C. Hadley purchased the *Avondale Star* from J. Thomas Baker that same year and renamed the paper the *Avondale Herald*. The newspaper office was located on the south side of State Street in the seed store of Warren Shelmire next to the Philadelphia and Baltimore Central Railroad tracks. The first issue of the *Avondale Herald* was printed on April 17, 1896. The editorial in that issue stated, "with this issue the Avondale (weekly) Herald succeeds the monthly Star." In the photograph above, Anderson is seen setting type in the *Avondale Herald* office in 1896, and in the 1898 photograph below, Anderson is addressing, by hand, the *Avondale Herald* newspapers.

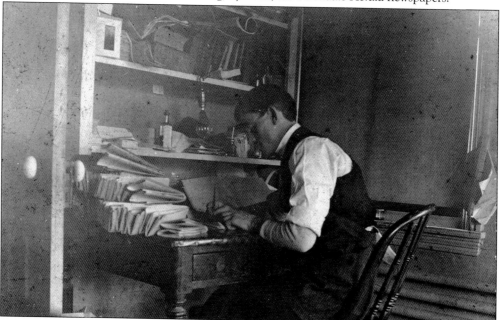

The Avondale Star.

THE AVONDALE STAR,

PUBLISHED EVERY MONTH BY

J. THOS. BAKER,

AVONDALE, CHESTER COUNTY, PA.

Subscription, 35 cents per year, strictly in advance.

Advertising Rates: — Regular advertisements $1.00 an inch per year; single insertion, 15 cents. For further information call on or address

J. T. BAKER,
Avondale,
Pa.

AVONDALE, DECEMBER, 1894.

Some of our esteemed contemporaries seem to think THE STAR will not succeed. We only ask them to wait for a year or so and we will try and avert their fears on that point.

Rumor has it that some of our citizens are thinking of starting an ice plant. It would be a good thing if something of the sort could be started in Avondale. There is plenty of water and good railroad facilities here, and it seems as though a plant of that kind could not go a-miss. Let it be started by all means.

The people of this place should patronize the excellent course of lectures given by the Bachelors' Club in Watson's Hall. So far they have had a good attendence.

THE STAR is not going to stand still in '95. We want to hear more from our home friends. Remember our columns are always open to all correspondence reaching us again the first of the month.. We have made the following offer: Any one sending us one new subsciber at the regular rates will get a copy of THE STAR for 6 months free. This offer is good only until Jan. 1st.

With this month the Avondale Printing House begins its second year. We thank our friends for their kind patronage.

Borough Affairs.

A few items of interest to the citizens of Avondale and Vicinity.

There seems to be a report current that a petition is to be circulated to restrain the borough fathers from borrowing any more money. What good a petition would do we fail to see. Turn out at the next spring election and turn the rascals out.

Why not take more interest in the doings of the borough? The meetings are open to all, and the kindly advice of citizens would be thankfully received. The council is elected to look after the interests of the borough. It is composed of representitive men who have as much at stake as onyone in the village. It would hardly be expected that they would do anything to injure their own business, or to the detriment of their fellow cisizens. It is good policy for the council to keep the tax rates as low as possible, and yet there are borough improvements absolutely necessary which cannot be had without borrowing money. Provision being made for interest and sinking fund this imposes no additional duty.

Avondale has natural advantages, which with united effort could be made of lasting benefit to all. What is needed is a cultivation of self-respect in a town sense.

The streets must be graded and put in order; sidewalks must be laid. No one would think of inviting a friend to a dirty, ill kept house. How can we expect strangers to settle among us, industries to start in our midst, unless we show that we have the spirit and push of the 19th century. There are numerous other things to do besides those above mentioned, but they will do for a beginning; but above all things let us have self respect and determination to pull together for a common cause.

Probaly the most important public improvement is the erection of waterworks. The cost would be trifling in comparison to the advantages and the more certain protection against fire. Let the works be owned by the borough and not by a corporation. There could not be a better investment or money spent to a better advantage.

In December 1893, J. Thomas Baker established the Avondale Printing House in the seed store of Warren Shelmire, located on State Street near the Philadelphia and Baltimore Central Railroad. The Avondale Printing House was a job printing business that printed envelopes, note-heads, billheads, and flyers. In October 1894, Baker began publishing the *Avondale Star*, a monthly six-by-nine-inch newspaper. The first three issues of the *Avondale Star* were free, and after that the cost was 35¢ per year for 12 issues. An editorial in the December 1894 issue of the *Avondale Star* stated, "with this month, the Avondale Printing House begins its second year." In April 1896, Baker sold the Avondale Printing House, including the *Avondale Star*, to Charles Hadley, owner of the *Kennett News and Advertiser* in Kennett Square. At that time, George L. Anderson became manager of the newspaper, and the name was changed to the *Avondale Herald*.

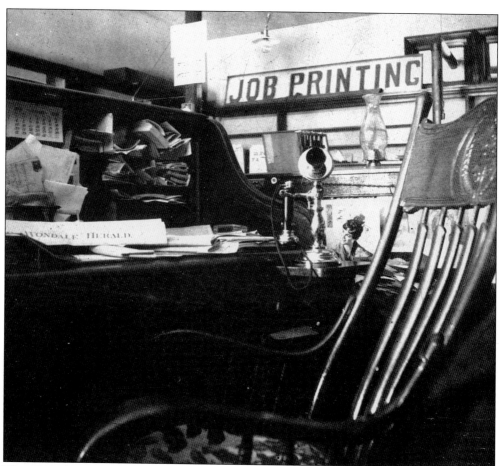

This 1898 photograph of the *Avondale Herald* office on State Street depicts George Anderson's desk with an issue of the *Avondale Herald*. Anderson was editor and proprietor of the *Avondale Herald* for 24 years from June 17, 1898, until July 1922, when he sold the newspaper and his job printing business to John W. Jones, the editor and proprietor of the *Kennett News and Advertiser*. The July 14, 1922, issue of the *Avondale Herald* announced the ownership change from Anderson to Jones. Pictured below is a receipt for a year's subscription to the *Avondale Herald* issued in 1905. Throughout the years that Anderson was proprietor and editor, the yearly subscription was always $1.

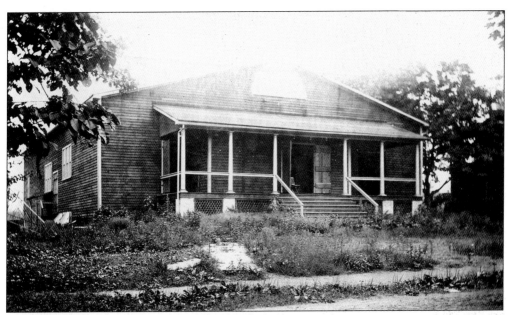

The partnership of James L. Paiste and J. Howard Brosius purchased a parcel on the north side of State Street from the Building Association of London Grove on August 1, 1904, for $662.50. Soon after their purchase, the Avondale Lecture Hall was constructed on the site and provided entertainment for the citizens of Avondale and the surrounding communities. Paiste and Brosius later sold the Avondale Lecture Hall property for $1,100 to James L. Pennock, a partner in the Pennock and Brosius Flour and Feed Mill, which was located on land at the rear of the hall. The building was then used as a storage facility. Later the Chester-Delaware Farm Bureau Co-Operative Association purchased the building and also used it as a storage facility. The above photograph is the Avondale Lecture Hall in late 1910 and the photograph below in 1942.

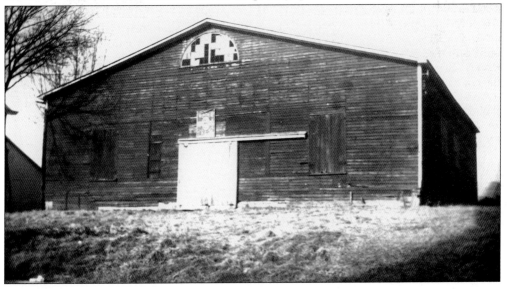

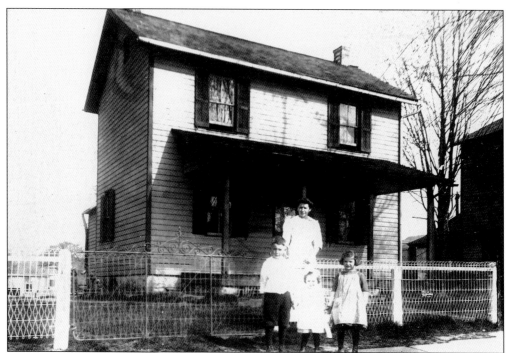

In November 1868, Daniel Kelly, a laborer on the Philadelphia and Baltimore Central Railroad, purchased a parcel of land from Patrick Riley, and in 1869, he erected this frame home that still stands on the north side of State Street across from the present Avondale Waste Water Treatment Plant. The Charles Cleveland family occupied this home for over 50 years. Pictured here in this 1915 photograph is Belle Mullen Cleveland with her children, from left to right, Hugh, Anna, and Esther Cleveland.

Once part of the 11-acre Avondale Iron Foundry and Machine Works property, this quarry along Indian Run Road served for a number of years as the reservoir for the Avondale Water Company. In August 1874, Chandler Phillips, the proprietor of the Avondale Hotel, opened and operated the quarry and received substantial orders for the available stone and flagging. The photograph is a view of State Street from the quarry in 1940.

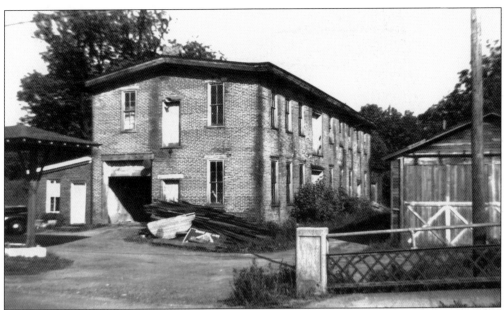

In April 1868, John James, John S. Carlile, and James Watson purchased, from George S. Jones of Philadelphia, 11 acres adjoining the White Clay Creek (also known as Miller's Run), located on the south side of the then State Road to New London. Soon after, the Avondale Iron Foundry and Machine Works was established. The above pictured building, completed in April 1869, was the main building, measured 30 feet by 150 feet, and was constructed of brick from the Avondale Brickyard; it was used as the machine shop and planing mill. Below is pictured a separate building, measuring 24 feet by 36 feet, also of brick and located just south and to the rear of the central building, that was used as the plow casting shop. Today the Avondale Waste Water Treatment Plant occupies this site.

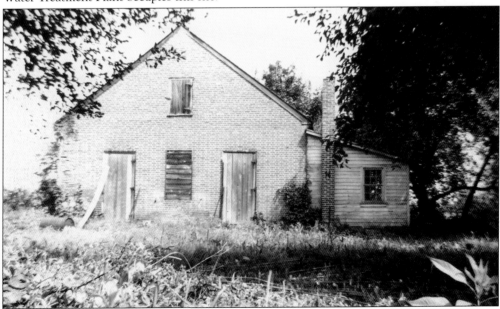

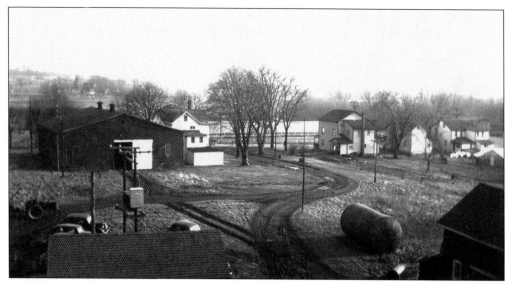

Early deeds of properties on the north side of State Street from the Philadelphia and Baltimore Central Railroad to the lane depicted here refer to the right of the owners of the Bark Mill Tract "to have ingress and egress and free and unrestricted use at all times of a certain lane or street over the said land from the State Road." The lane, shown here in 1944, is still in existence as the State Street entrance to Edlon.

On May 27, 1867, Patrick Riley, a foreman on the Philadelphia and Baltimore Central Railroad, purchased 12 acres that were, as stated in the deed, "part of a large tract called 'Avondale,'" located on the north side of State Street next to the White Clay Creek. His home, built in 1868, continues today as a private residence. Pictured in this 1900 photograph are Jane Riley and Patrick Foley.

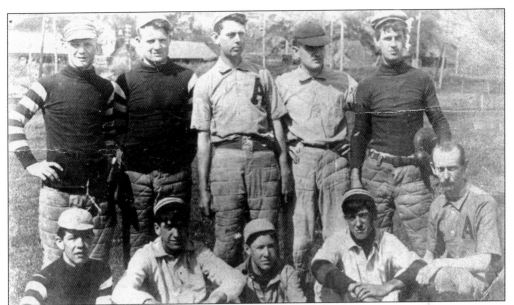

This photograph of the Avondale baseball team appeared in *Spalding's Official Philadelphia Base Ball Book of 1910*, even though the photograph is of the 1908 team. Pictured are, from left to right, (first row) Fred Greenfield, Frank Pugh, Carlton Thomas, Jack Pugh, and M. McLaughlin; (second row) John Miller, Roy Miller, Edward Thomas, Charles Pusey, and "Buff" Nichols.

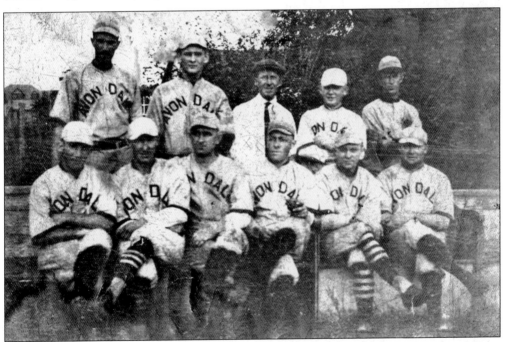

The 1910 Avondale baseball team pictured here finished second in the league standings. Some of the opposing teams were Doe Run, West Grove, Kennett, Concord, Toughkenamon, Chrome, and Unionville. Pictured are, from left to right, (first row) Harold McCue, Carlton Thomas, Peck Husband, Fred Robinson, Joseph Johnson, and Roy Miller; (second row) Milton Durnell, Donald Chandler, Martin Grace, John Miller, and unidentified.

53

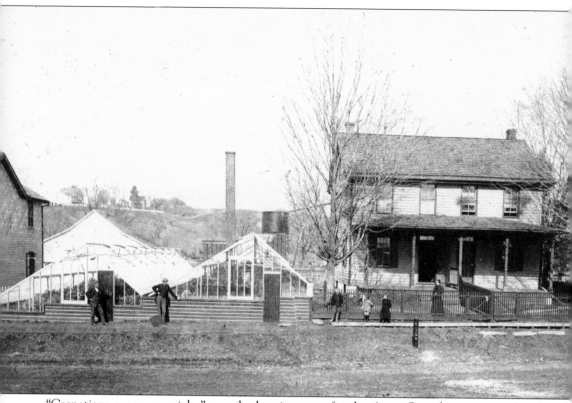

"Carnations are my specialty" stated advertisements for the Avon Greenhouses, owned and operated by Enoch J. Cloud and located on the north side of State Street near the White Clay Creek. Cloud purchased several parcels of land from Patrick Riley and in 1893, began his greenhouse and florist business. In 1904, when the business was sold to the Renard brothers of Unionville, their purchase for $4,000 included a double residence, greenhouses and contents, and an unimproved lot of ground. The building to the right is Cloud's residence, and in the early 1870s, Elma and Anna Walton conducted a trimming and notions store in the building. Pictured in this 1897 photograph are, from left to right, Cloud, Warren Shelmire, three unidentified children, and Annie Cloud.

Three

SCHOOLS AND CHURCHES

The Reverend John L. Hood, the congregation of Galilee UAME Church, and a number of local citizens gathered at the church located on the north side of East Third Street at the White Clay Creek on Sunday, July 16, 1899, to lay the church's cornerstone. The building was the former New Garden schoolhouse, purchased by Hood in 1898. The church is pictured here in November 1936.

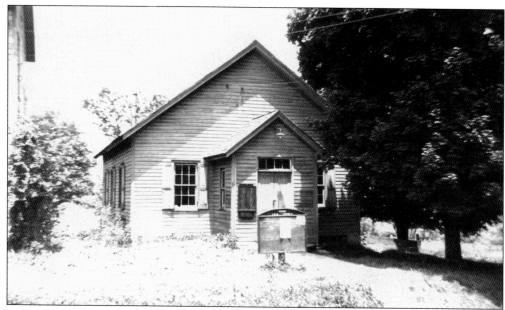

In September 1898, the Reverend John L. Hood, Methodist clergyman and Avondale's first African American borough councilman, purchased a building and lot located on the north side of East Third Street at the White Clay Creek from the Avondale School District. This structure was to become the second, and current, church for the Galilee UAME congregation. On July 16, 1899, the cornerstone was laid. The building was built in 1884 by the New Garden School District on land purchased from James Watson in September 1884 for $200. In January 1885, Chandler Phillips presented the directors of the new school with a bell for the school belfry. The photograph above depicts the church in 1943, and in the photograph below the congregation is shown after Sunday services in 1945.

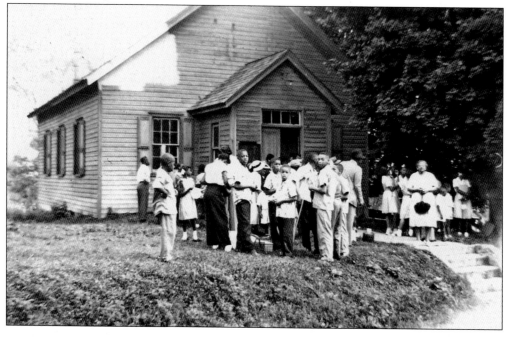

Formerly a coach maker's shop, the dwelling pictured above in 1942 is located on the southeast corner of Second and Chatham Streets and was the first public school in the village of Avondale. Having purchased the lot and dwelling from James Watson in 1871, the Building Association of London Grove sold the property to the London Grove School District in 1872. The building served as a school from 1872 until 1873, when the building pictured below was erected on the southeast corner of Fifth and Chatham Streets on a lot that the school district eventually purchased from Watson in 1876. This photograph is dated May 1893.

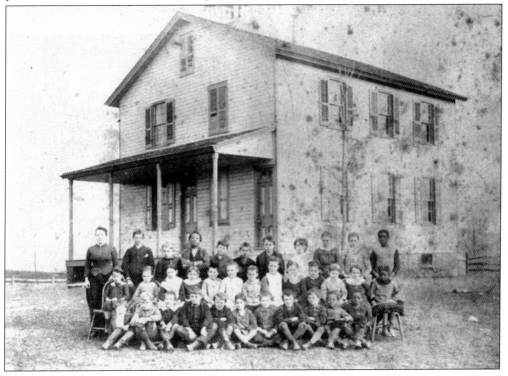

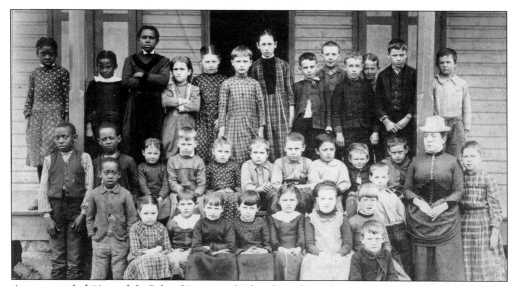

An essay titled "Avondale School" written by local resident Eleanor H. Cooper in 1956 for May Day notes that in 1891, tuition was $1.50 per month and the school term was eight months. This 1891 photograph depicts the students of the Avondale Grammar School located on Chatham Street at Fifth Street. The only identified students are the fourth and fifth students from the left in the third row, Wilhelemene Quarll and Clara Belle Mullen.

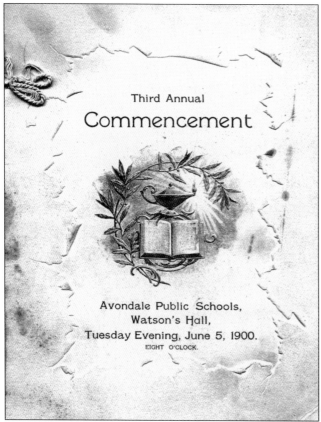

The nine graduates and two postgraduates of the Avondale Public School class of 1900 held their commencement exercises in Watson's Hall on June 5, 1900. Hugh A. McMaster gave the class oration titled "The Four Boxes," and Ruth F. Harper recited the class essay titled "Neglected Opportunities." Pictured is the cover of the 1900 commencement program, which was printed by the Avondale Herald Electric Print.

On January 5, 1870, Joshua Baker Steward, the pastor of the Avondale Methodist Episcopal Church, and Lewis Bahel purchased, from James Watson for $210, a lot that was known as Back Lot Number Four, one of the lots on a "Plot of Lots of Avondale," located on the northwest corner of Second and Chatham Streets. The trustees of the Avondale Methodist Episcopal Church purchased the lot, which now included a house, on April 3, 1886, from Septimus E. Nivin, guardian for the minor children of John James, deceased, at private sale for $1,000 for use as the church parsonage. The Avondale Methodist Episcopal Church sold the parsonage in 2001, and it is now a rental property. Over the years, the congregation held many social events in the parsonage. One such event is recorded in the invitation below.

This Stocking and Card will admit you to an Entertainment at

Avondale M. E. Parsonage,

WEDNESDAY EVENING, SEPTEMBER 14TH, 1904.

Please bring this little stocking too; you need not think to wear it,
 But put in pennies, just a few, not quite enough to tear it;
As many as the size you wear, yes, that or even double
 Won't be to much for you to bear, but 'twill help us end our trouble.

P. S.—If you cannot come it will be quite shocking,
 But send us, please, this little stocking.

This 1905 photograph is of the Avondale Methodist Episcopal Church, located on the southwest corner of Second and Chatham Streets. It was the second structure used by the church and was completed in late 1880 to replace a two-story frame structure that had partially burned in 1879. This church was dedicated on Sunday, February 13, 1881. The previous two-story structure was built in the spring of 1870 at a cost of $1,400.90, on land purchased by Joshua Baker Steward from James Watson on September 2, 1871. The first floor was used as the church, while the second floor was used as the Avondale Select School, a private school conducted by the church's pastor, Steward. While this second church was being built, the church held services in the hall located over the stone warehouse on the west side of Pennsylvania Avenue, where the Maximum Fitness building is now located. In 1882, the mortgage and judgment bond were paid off, and the church requested conveyance to the trustees of the church.

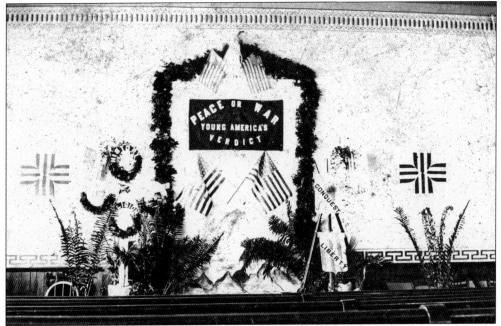

On Sunday, March 13, 1898, Rev. R. E. Johnson, pastor of the Avondale Methodist Episcopal Church, preached a sermon titled, "Peace or War and God's Way," referencing a possible war with Spain. The interior of the church, shown in this 1898 photograph when the church was located at the southwest corner of Second and Chatham Streets, was decorated by the Epworth League, the church's youth organization.

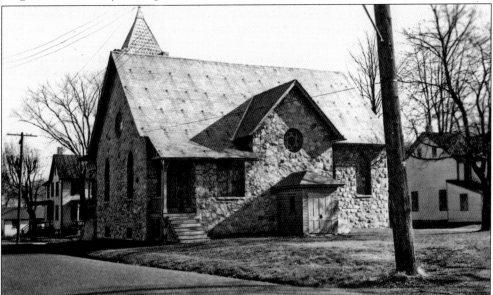

In 1900, the Avondale Methodist Episcopal Church congregation began a fund for the building of a new church. A lot was secured on the southwest corner of Third and Chatham Streets, ground was broken for the new church in April 1907, and the dedication of the gray limestone church was held in November. The total cost including the lot, building, and furniture was $8,600. This photograph depicts the church in 1928.

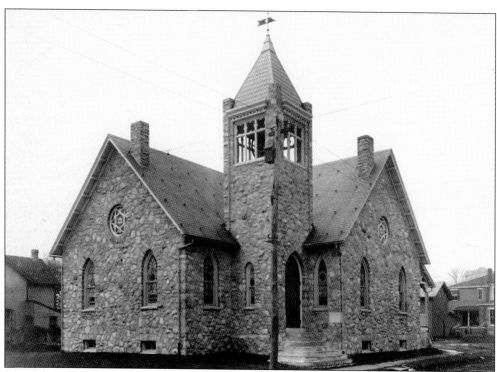

The Avondale Methodist Episcopal Church was established by the Reverend Joshua Baker Steward in October 1868 at his home on the north side of State Street near the Philadelphia and Baltimore Central Railroad station known later as the Lipp Building. The photograph above depicts the third church building erected by the congregation, located on the southwest corner of Third and Chatham Streets. It was built in 1907 on two 50-by-175-foot lots purchased from congregant Mary Henderson, which were originally purchased by Isaac Miller from James Watson in 1870 for $300 and were designated as "Back Lots" number eight and nine on the "Plot of Lots of Avondale." Pictured below is the interior of the church in the early 1920s.

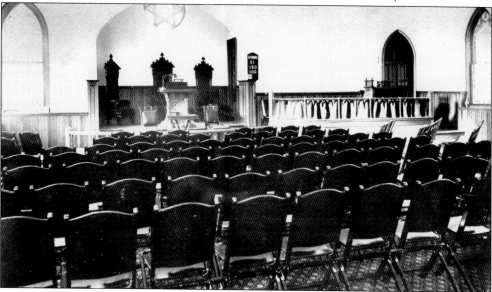

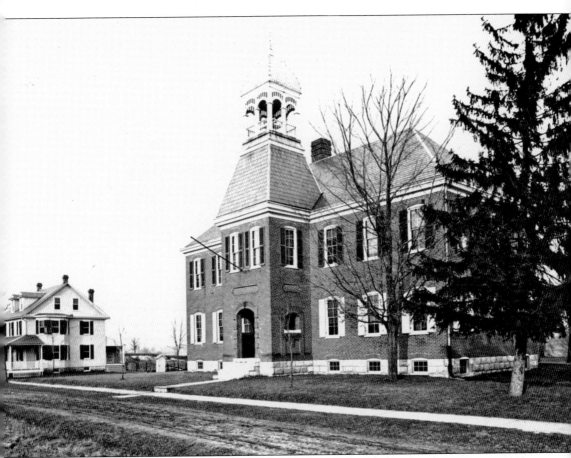

In March 1898, the school directors of the Borough of Avondale adopted plans for the erection of a new two-story brick schoolhouse to replace an existing frame structure located on the east side of Chatham Street. The same month, the school directors advertised for and received bids for the construction of the same, and work on the new schoolhouse was to begin after the current school term was over. Charles Moore of Kennett Square began erecting the new schoolhouse after tearing down the old frame one in May of that year. In May 1913, construction began on a two-story brick addition that was to be added to the main school building. That same year, the curriculum was changed, adding a third year to the high school course, and additional teachers were employed to accommodate the growing number of students. In 1912, Tuesday and Thursday evening classes in English were offered for the benefit of the Italian immigrants. The photograph depicts the school around 1910. Today the school building is privately owned.

Class of Nineteen Hundred Twenty-four
Avondale Vocational School
Commencement Exercises
Wednesday evening, May twenty-eighth
at eight o'clock
Watson's Hall

The class of 1924 was the largest class, to that year, to have graduated from the Avondale Vocational High School. The baccalaureate service for the class was held at the Avondale Methodist Episcopal Church, and Watson's Hall was the scene for the commencement exercises. "Do more than you are paid to do" was the title of the talk given by Professor Helm of the West Chester State Normal School. The highlight of the evening was a three-act play titled *A Double Proposal* presented by the graduates. The graduates are, from left to right, (first row) Mildred Webb, Wenonah Nichols, Myrtle Wilkinson, Sabylla Montgomery, principal D. E. Womer, Mary Walker, Elizabeth Connell, and Evelyn Cleveland; (second row) Edith Passmore, Worrell Tingley, Charles Chambers, Joseph McClellan, Herman Anderson, Wayne Nesbitt, and Mary Singles; (third row) Albert Jenkins, Walter Sheehan, Omar Johnson, Timothy Quinn, Leslie Richardson, Franklin Cooper, Edward Strode, and Norman Johnson. Graduating, but not pictured, were Ralph Richardson and Benjamin Connell.

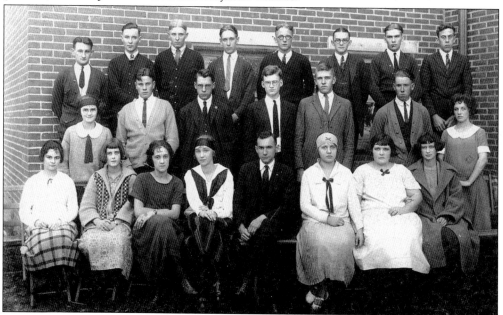

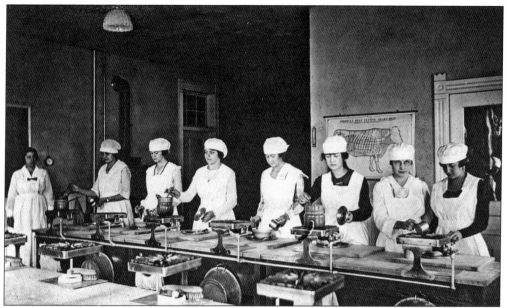

The domestic science cooking class of the Avondale Vocational High School is shown here in 1919. The class prepared and served hot lunches at noon for 5–11¢ a dish, planned the menus, ordered materials, collected the money for the meals, deposited it in the bank, and purchased all the groceries that were to be used. The participants in the photograph are unidentified.

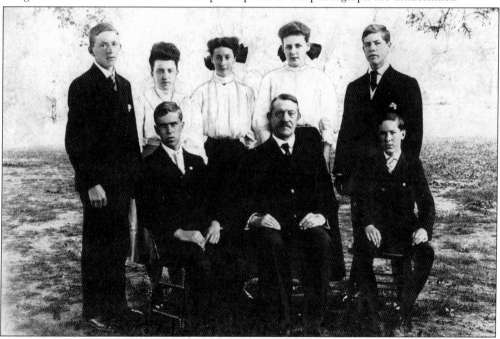

The tenth annual commencement of Avondale High School was held on Thursday evening, May 29, 1907, at Watson's Hall. The graduates of the class of 1907 pictured here are, from left to right, (first row) Percy B. Skelton, principal William H. Snyder, and Carleton M. Thomas; (second row) John A. Connell, Eva M. McCue, Marion H. Keating, Esther R. Good, and Fred J. Greenfield.

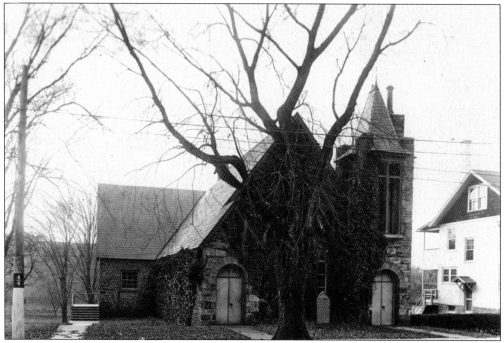

Howard L. Hoopes sold a parcel of land located on the west side of Pennsylvania Avenue across from Fifth Street on March 1, 1873, to the Presbyterians of Avondale for $400. Construction soon began on the church that was dedicated in 1874. In September 1890, a contract was awarded for the erection of a bell tower, and a new stone addition to the church was dedicated on October 9, 1909. A manse, south of and adjacent to the church, was completed in 1925, and another addition to the church, the Christian Education Building, was dedicated in October 1965. In February 2007, the Christian Education Building was demolished, and a new church building program was begun. The above photograph depicts the church in 1920, and the photograph below depicts the church in 1947.

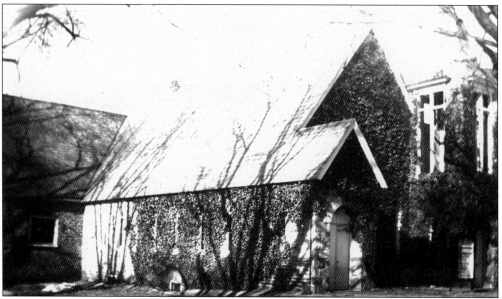

Early records confirm that the African Methodist Episcopal Zion Church in Avondale was in existence as early as December 1875. The minutes from a meeting held at Avondale on January 20, 1876, were published in the *Christian Recorder*, an early African American newspaper. On April 1, 1892, John H. Turner and his wife, Louisa, sold, for the sum of $1,400, a lot and brick building in Avondale, New Garden Township, located on the west side of Church Street to Lewis Brown, Charles Boyer, Benjamin Rhoads, William Bostic, Joseph Duckery, Albert Anderson, and Stephen Wells, trustees for the African Methodist Episcopal Zion Church of Avondale. The members of Mount Tabor African Methodist Episcopal Zion Church still worship in this brick church. This photograph below shows the choir at Sunday services in 1955. From left to right are Joanne Brown, Gwendolyn Johnson, Ruth Boddy, Doris Thompson, and Barbara Harris.

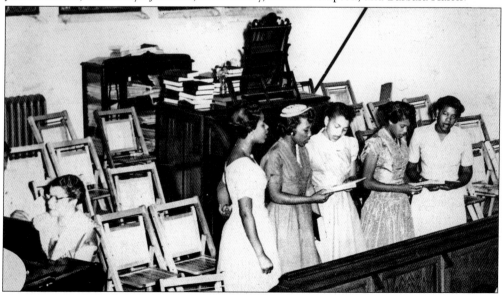

Prior to 1875, a number of African Americans living in New Garden Township, London Grove Township, and the village of Avondale worshipped in a log church, located in the 300 block of the present Church Street under the leadership of George Walker, who was then living in London Grove Township. The exact location of this building is not known. On August 7, 1880, Stephen W. Butcher, Alexander Johnson, Isaac Cooper, George Walker, and James Rhoads, the trustees of the African Methodist Episcopal Zion Connection purchased a parcel of land located on the east side of Church Street for $25 from Henry Lewis and his wife, Summina, of New Garden Township, owners of 17 acres of land in that township. Soon thereafter, the congregation erected a small frame church. On November 2, 1891, the trustees of the African Methodist Episcopal Zion Connection sold the property. In 1895, the property was sold to the Reverend Isaiah Watson and was used by the Galilee UAME Church congregation. This photograph depicts the church when it was a private residence in the 1960s.

Four
PENNSYLVANIA AVENUE

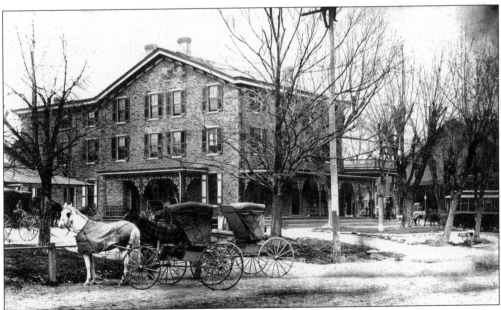

Although research has failed to establish the exact date of its construction, it is known that the Avondale Hotel, which was located on the northwest corner of Pennsylvania Avenue and State Street, was in existence in 1856. Chandler Phillips purchased the two-acre hotel property in March 1868 from his father-in-law, James Watson. This 1905 photograph views the Avondale Hotel looking northeast from State Street.

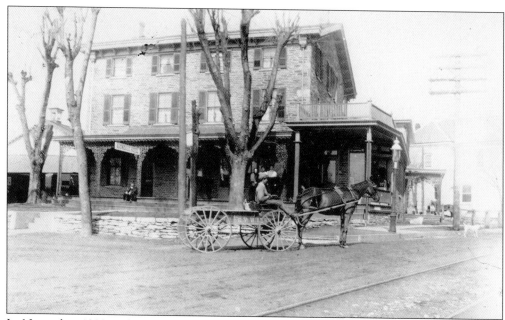

In November 1889, Robert L. Pyle and Charles Y. Wilson purchased the two-acre Avondale Hotel property at public auction from the estate of Chandler Phillips for $10,500 and remodeled the downstairs of the hotel for use as a store. Shortly thereafter, the firm of Pyle and Wilson moved their general store to the hotel. On November 18, 1904, Wilson purchased all of Pyle's share and interest in both the real estate and the store merchandise. The photograph above is the south side of the hotel facing State Street and C. Y. Wilson's delivery wagon in 1907. The photograph below also depicts the south side of the hotel with C. Y. Wilson's store in the east corner, and pictured are, from left to right, Belle Mullen, Charles E. Cleveland, unidentified, Robert K. Mackey, and Charlotta E. Cleveland.

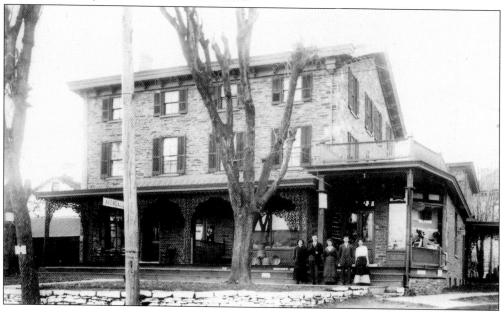

Over the 80-plus years of its existence, the hotel had been known by a number of names, including the Avondale Hotel when Chandler Phillips was owner and innkeeper in the 1860s through the 1880s; both Avondale House and Avondale Temperance Hotel and Boarding House when Frank Pennock was innkeeper in 1891; Avondale Temperance Hotel when Richard B. Chambers was innkeeper in 1904; and Avondale Hotel and Restaurant when Charles Y. Wilson was the owner in 1915. When Pennock was innkeeper, an advertisement in the *Chester County Business Review for 1891* noted that the proprietors strictly conducted a temperance hotel that accommodated both permanent and transient guests. At this time, the hotel contained 17 well-furnished sleeping apartments, stabling for 40 horses, and shedding for 25 teams. When Jesse M. Bundy and his daughter Anna B. Jacobs became proprietors of the Avondale Hotel in 1906, they advertised that the hotel was under new management; it had been thoroughly renovated, freshly papered, newly furnished, and every bedroom steam heated. Pictured is a page from the Avondale Hotel Register from June 20 and 21, 1907, when Bundy was proprietor.

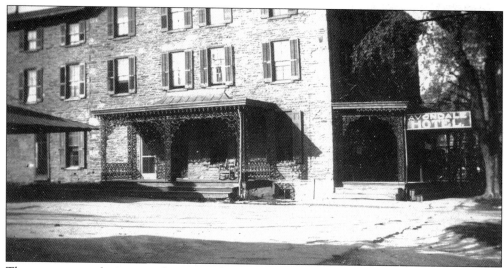

The ornate wrought iron porches, manufactured by John James at the Avondale Iron Foundry and pictured in this 1912 photograph of the Avondale Hotel, were erected in 1879 when Chandler Phillips was the hotel's owner. Phillips had made other improvements to the hotel during his tenure as innkeeper by adding a soda fountain in 1873, an addition to the rear of the building in 1874, and a carriage shed in 1880.

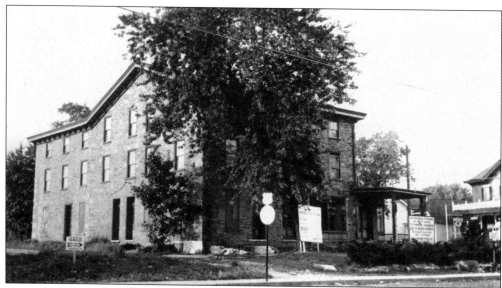

On August 17, 1922, Charles Y. Wilson retired and sold his general store, which included the fixtures, merchandise, and goodwill to Gordon and Richmond of Philadelphia. However Wilson retained ownership of the hotel property until 1927. In 1936, after sitting empty for a number of years, the hotel was demolished to make way for a new gasoline and service station. In this 1936 photograph, the hotel is pictured empty and for sale.

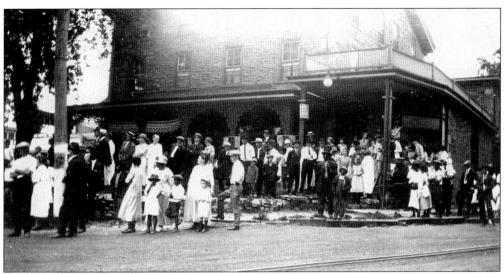

The Italian residents of Avondale and the vicinity, under the auspices of the Avondale Italian Republican Club, held a parade and flag celebration in 1920 to celebrate some recent citizenships. The parade assembled in front of William Blittersdorf's on State Street; participants marched up Pennsylvania Avenue, three miles to West Grove where services were held in St. Mary's Church, followed by a luncheon and social time. Both the Avondale and West Grove Fire Companies participated, as did the Italian Lodge from Wilmington, Delaware. The *Avondale Herald* noted that music was provided by the T. Territe band from Philadelphia. The photograph above depicts the public assembling at the Avondale Hotel to view the parade, and the photograph below depicts the parade passing the east side of the hotel on Pennsylvania Avenue.

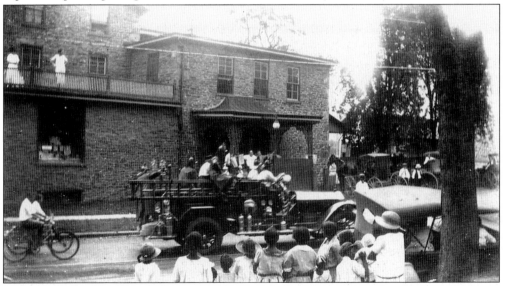

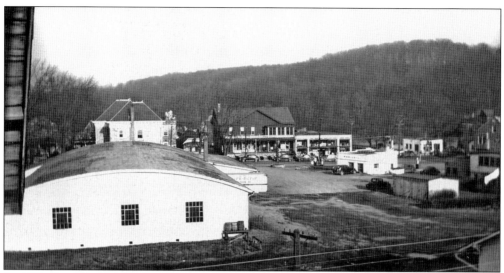

In 1939, Evan B. Sharpless of London Grove purchased the Avondale Hotel property and in 1940 announced that he would soon be constructing a roller rink and restaurant on a portion of the property. On Monday evening, July 1, 1940, a grand opening occurred for two of Avondale's newest businesses: the Avon Roller Rink and Sharpless Dairy Lunch. In the first two months of operation, over 15,000 people had enjoyed the new skating arena. In August 1948, Sharpless sold the roller rink and restaurant property to Medford-Dunleavy of Avondale and Coatesville, which, in 1951, after complete renovations, opened their new appliance showroom on the premises. The photograph above shows the rear of the Avon Roller Rink at the left of the photograph with the Lamborn Block in the background; the photograph below depicts the interior of the Sharpless Dairy Lunch in 1944.

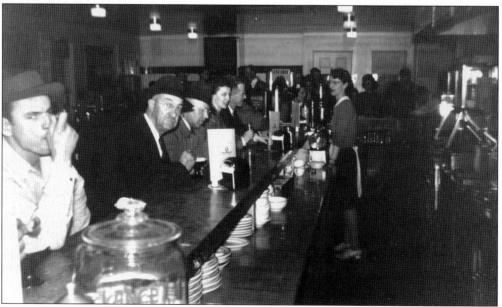

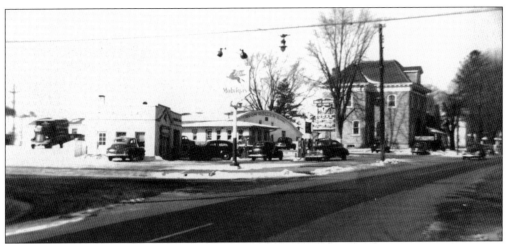

In August 1940, a group of the young skaters at the Avon Roller Rink formed the Avon Roller Club. The club held weekly meetings at the rink and sponsored a number of amateur competitions including artistic, dance, and speed skating. Sometime in the mid-1940s, the group disbanded, but a new club called the Avon Rollers was formed in March 1948. Membership was open to anyone over 15 years of age. The group sponsored several "Backward Parties" where the girls wore their attire backwards or inside out, and the boys wore their shirts backwards. In 1947, the rink supplied Chicago Shoe Skates, but the clamp-on skates continued to be a favorite with the skaters. The photograph above is a view of Pennsylvania Avenue looking north with the Avon Roller Rink and Sharpless Dairy Lunch at the left of the photograph, and the photograph below shows a group of skaters at the rink in 1943.

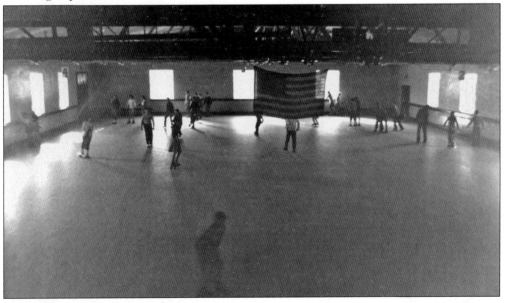

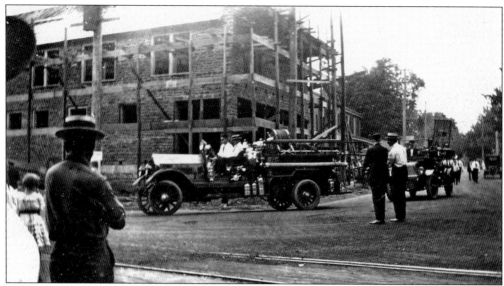

Caleb Cooper and Henry R. Pusey, dealers in wagons and farm implements, purchased an agricultural implements business located in a frame building on the southwest corner of Pennsylvania Avenue and State Street from Harvey M. Cook on February 24, 1899. In 1906, the partnership was dissolved, and in March 1908, Pusey purchased the building from Robert L. Pyle and established H. R. Pusey and Company. In 1923, the frame building was razed, and a new building of stone was erected. In 1931, the company name was changed to the J. Norman Pusey Company. The two photographs depict views of State Street looking west from First Street during the Fourth of July parade in 1922. The new construction of the H. R. Pusey store is at the left in each photograph.

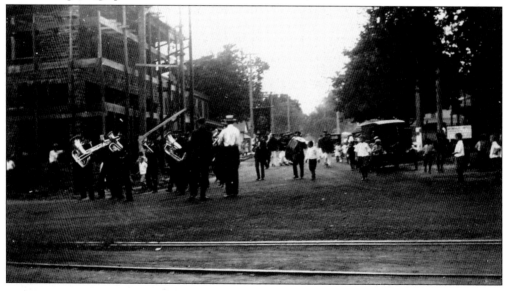

Numerous attempts had been made to establish an electric railway (trolley) in the borough of Avondale. In 1900, the Oxford and Kennett Railway received permission from council to lay track, but the burgess vetoed this action. January 1902 saw permission granted to the Vandergrift-Tennis Company, but council later annulled the permission. The West Chester, Kennett, and Wilmington Electric Railway Company received permission in June 1903, and the trolley entered Avondale as far as the county bridge on Pennsylvania Avenue in 1904. Finally in January 1905, Thomas O'Connell, having procured a franchise to lay track from Avondale to West Grove under the name Oxford, West Grove, and Avondale Street Railway Company, completed the remainder of the track on Pennsylvania Avenue. The photographs above and below show Pennsylvania Avenue looking north from State Street in 1905, the lower after the trolley track was laid.

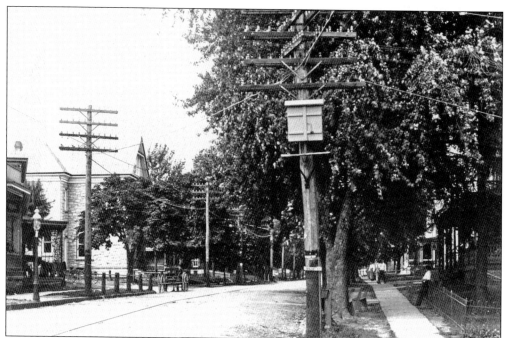

When contractor Thomas O'Connell received permission from the Borough of Avondale to extend the trolley line northward on Pennsylvania Avenue, part of the agreement was that he would repair, level, and macadamize the main street over which the trolley traveled. These improvements, begun in August 1906 by Corcoran Brothers, were completed in November 1906. After many years of serving the community, the trolley went out of business in November 1929. The tracks on Pennsylvania Avenue were removed in 1937. The photograph above is Pennsylvania Avenue looking north from Front Street in 1909; the photograph below depicts Pennsylvania Avenue looking south from West Second Street in the mid-1940s.

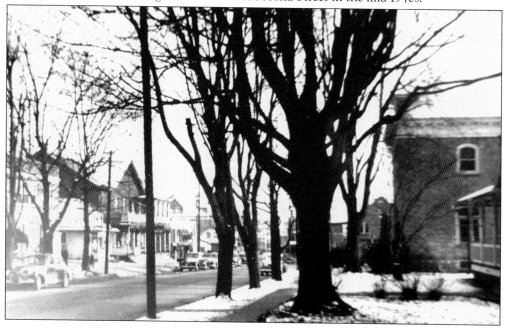

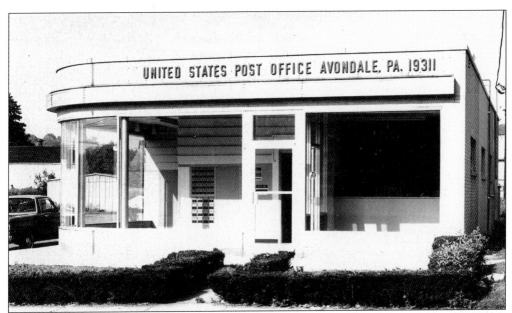

Prior to 1828, Avondale residents received their mail from the New Garden Post Office. The Avondale Post Office was established on December 29, 1828, at the mill located on what is now Ellicott Avenue just below the William Miller house. From 1889 until 1914, the post office was located in the Lamborn Block on the east side of Pennsylvania Avenue, and from 1941 until 1968, the location was the southeast corner of Pennsylvania Avenue and Second Street. The post office moved to its present quarters, under postmaster Gerald Kilmer, on September 27, 1968. In its almost 180 years of existence, the Avondale Post Office has had 26 postmasters and 9 different locations. The photographs depict two views of the new post office just prior to its opening in 1968.

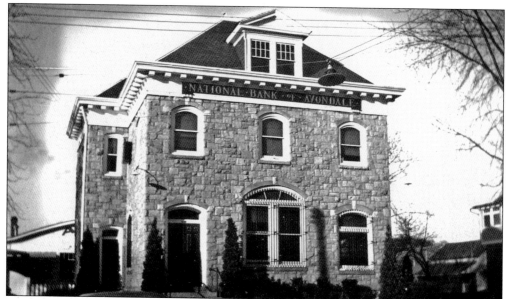

On September 13, 1895, the directors of the National Bank of Avondale purchased from Robert L. Pyle and Charles Y. Wilson a parcel of land 45 feet by 85 feet, located on the west side of Pennsylvania Avenue adjacent to the Avondale Hotel, for $1,000. In the fall of 1896, the new bank was completed and the doors opened to the public. In the spring of 1909, the building was renovated and enlarged. This photograph shows the bank in 1946.

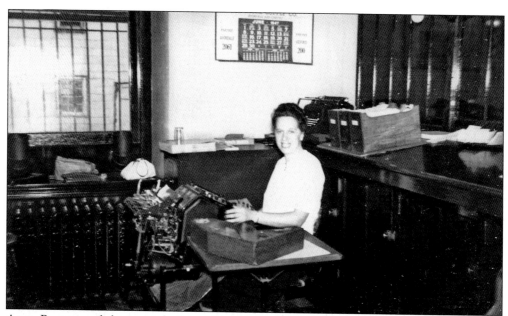

Anna Rosazza and the interior of the National Bank of Avondale are shown here in this June 1947 photograph. Rosazza began as summer help at the bank in June 1924 and worked three days a week until December 1925 when she became a full-time employee. She was also, for a time in the 1930s, the auditor for Avondale.

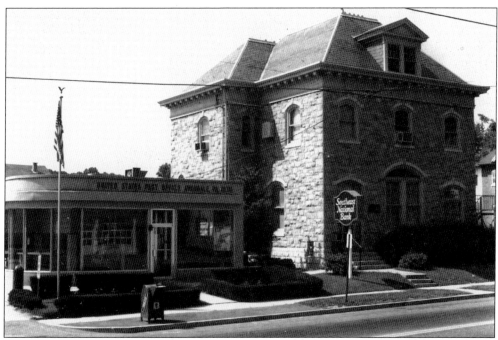

The National Bank of Avondale became a branch office of the National Bank of Chester County, and in 1970, a merger between the National Bank of Chester County and Delaware County National Bank created Southeast National Bank of Pennsylvania. In 1983, the bank was acquired by Fidelcor, the holding company for Fidelity Bank of Pennsylvania. While a branch of Southeast National Bank, it underwent a complete remodeling. The photograph above depicts the bank in 1970 at the time of the merger, and the photograph below depicts the ribbon cutting for the remodeling in 1970. Pictured are, from left to right, Evan T. Chambers, William Cubbage, Henson M. Evans Jr., Peter Rizzotte, T. Linton Mercer, William P. Harris, and Jesse D. Pusey. In the background (face not seen) is Robert Gordon.

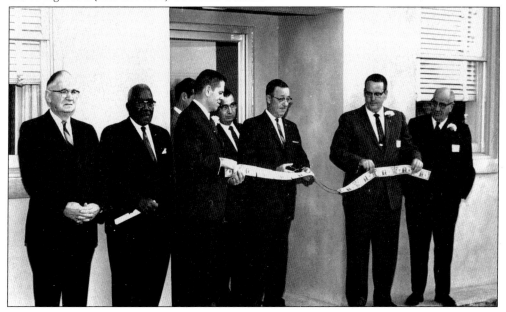

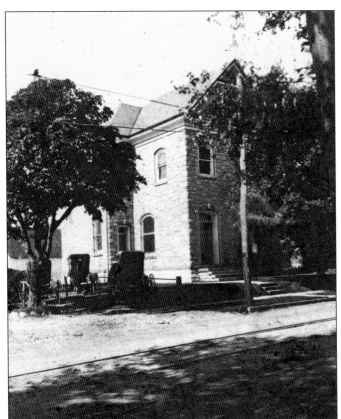

On December 11, 1924, the Bell Telephone Exchange was moved to the second floor of the National Bank of Avondale. At the time, there were 282 subscribers and 129 lines being served by two switchboards; 24 hour service was being provided. The photograph shows the bank in 1909.

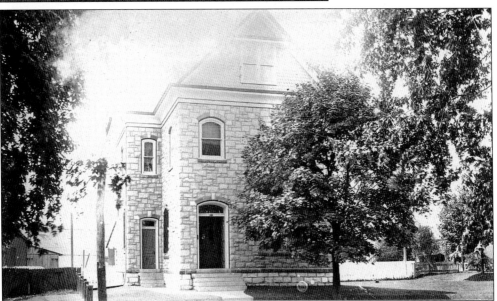

On October 2, 1916, the Avondale Library moved to a small second-floor room on the south side in the National Bank of Avondale. At that time, the library had 250 books. The bank did not charge for rent, heat, or lighting. The library moved to the Herald Block in February 1929. The photograph depicts the bank in 1905.

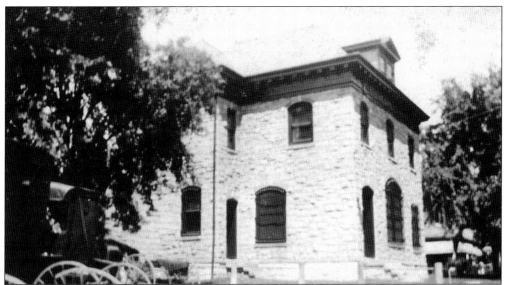

In 1895, when Charles T. Moore of West Grove drew plans for the proposed new National Bank of Avondale building to be located on the west side of Pennsylvania Avenue, certain specifications were included: eight-inch boards, containing three nails each, were to cover the rafters and then to be covered with Peach Bottom slate held with two nails; the door plates and exterior steps were to be of Port Deposit granite; and all woodwork was to be of selected quartered white oak strictly clear of knots and other imperfections, seasoned under cover for not less than two years, and kiln dried by the Anderson Steam Process. The above photograph pictures the bank in 1902, and the photograph below shows the bank's tellers' area in 1942 with, from left to right, Eldon Shelly, unidentified, Edward Thomas, and Norman Pusey.

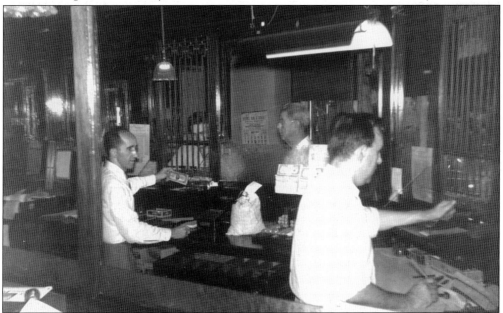

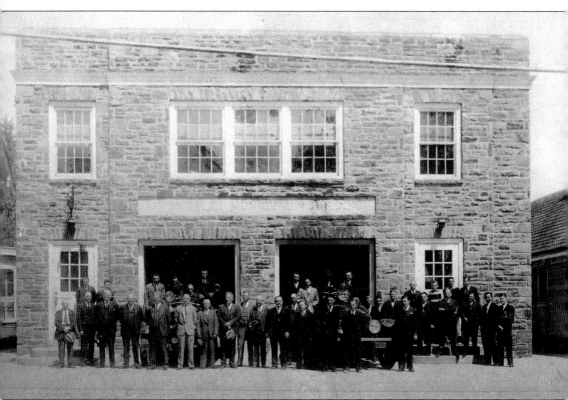

One of the largest and most comprehensive of Franklin D. Roosevelt's New Deal agencies was the Works Progress Administration (WPA), established in 1935 to provide jobs and income to the unemployed during the Great Depression. One project of the WPA was the Avondale Municipal Building, built in 1936 on a lot located on the east side of Pennsylvania Avenue near the Lamborn Block that the Borough of Avondale purchased from William H. and Nettie Lamborn for $1,000 on December 6, 1935. On September 20, 1935, Avondale Borough Council accepted the project of a new municipal building. The total cost was to be $7,050.19 for materials and $1,000 for the previously mentioned lot. In October of the same year, the plans for the new building were sent to Washington, D.C., for approval. By an agreement entered into between the borough and the Avondale Fire Company on August 9, 1937, the borough rented the building to the fire company for $1 per year with the fire company agreeing "to heat and light the Council Room and Lockup." The new building was dedicated on May 22, 1937.

In 1936, the Borough of Avondale issued Municipal Building Bonds in the amount of $8,000 at 3 percent interest to pay for the material for the erection of the building, the WPA having agreed to pay all labor for the same. The new building was to house the Avondale Fire Company, the Avondale Library, the Community Auditorium, the borough garage, and the lockup. The borough agreed to pay $100 per year rent for the Library Room and reserved the right to use the council chamber, garage, and lockup forever.

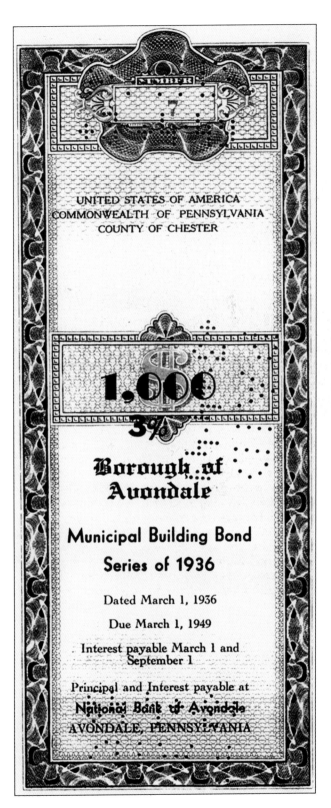

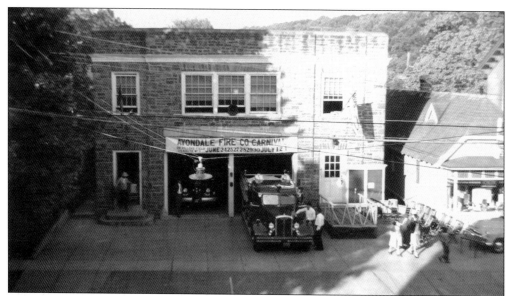

Sometime between November 1889 and October 1891, the Avondale Fire Company disbanded, as the *Daily Local News* stated, due to "lack of interest, and no fires having occurred." On September 19, 1892, a group of citizens met in the parlor of the Avondale Hotel to discuss reorganization. The reorganization occurred on September 26, 1892; officers were elected, and a need to raise funds was discussed. Over the years, in order to raise funds, the fire company has sponsored community events in the form of carnivals, fairs, and various programs. One such program was the "Forty Minstrals Gala" [sic] held in Watson's Hall in December 1897. The housing of new fire equipment has often coincided with these events. The two photographs depict preparation for a fire equipment housing in 1949, with a banner advertising a carnival to be held in June and July 1949 at Dillon's Field in London Grove Township.

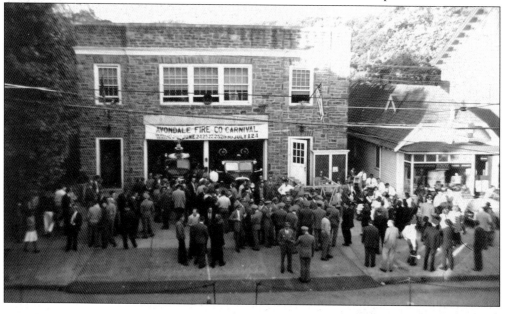

Joseph Henderson purchased a parcel of land located on the east side of Pennsylvania Avenue next to the Lamborn Block from Chandler Phillips in 1877 for $400. Later that year, Henderson built a small building that was to become his tailoring establishment. The building was home to a number of businesses in its nearly 85 years of existence, including Wood and Lamborn Electrical Contractors and Fecondo's market. In 1960, the Avondale Fire Company purchased and demolished the building to erect an addition to the firehouse. The photograph at right pictures the building when it was Richard Probst's market in 1958. The photograph below pictures the interior of Fecondo's Quality Market when it was located in the south end of Samuel Feldman's building in 1946, and seen are, from left to right, Philip Rea, Vincent Fecondo, and Guido Fecondo.

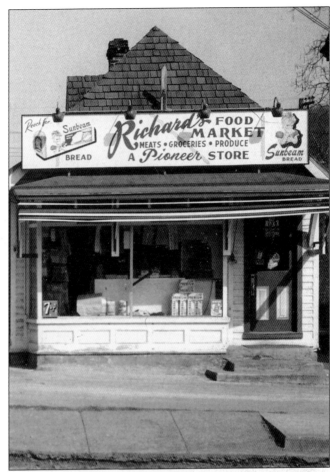

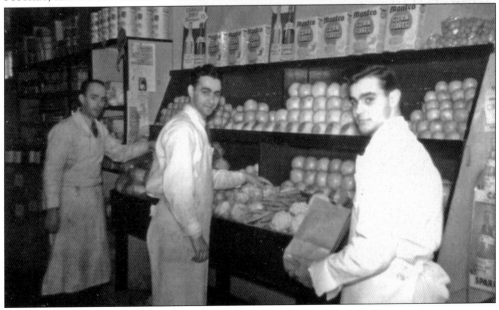

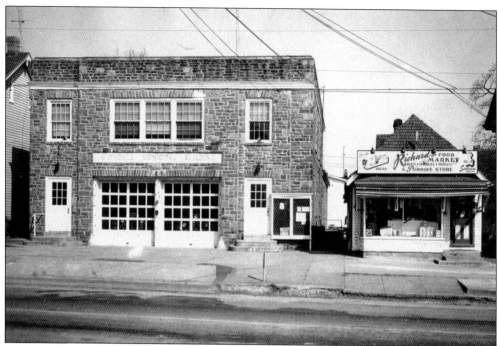

In April 1960, the Avondale Fire Company made settlement on property adjacent to their building and authorized the building committee to advertise for bids to construct a 27-by-49-foot addition to the firehouse. The following June, they accepted a bid from Coleman Brothers of West Grove for the construction of the addition, which would be concrete block, stuccoed, containing a stone front to match the existing stone fire company building. The addition permitted the company to house all of their fire equipment in one building; previously two trucks were housed in the Avondale Borough Garage. The above photograph pictures the fire company building prior to the addition in 1959, and the photograph below pictures the building with the addition in 1963.

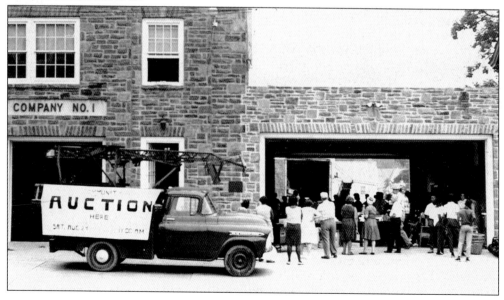

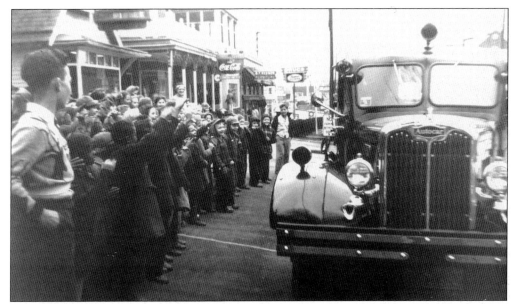

This February 1948 photograph depicts a group of Avondale elementary school children viewing the Avondale Fire Company's new Autocar chassis on display in front of the firehouse on Pennsylvania Avenue. The purchase of the truck was authorized in December 1947 at a total cost of $5,500. It was to be equipped with a portable pump and a 1,000 gallon steel tank that was to be manufactured locally.

The Avondale Fire Company housed their new Hahn, 1,500-gallon-per-minute pumper on October 10, 1981, and more than 70 pieces of fire apparatus from 18 volunteer fire companies participated. The pumper was dedicated in memory of Augustine Testa who had served the company as a volunteer for 35 years. Pictured at the dedication from left to right are Gerald Kilmer, Mary Testa, James DiCecco, Paul Testa, Augustine Testa, Richard Testa, and unidentified.

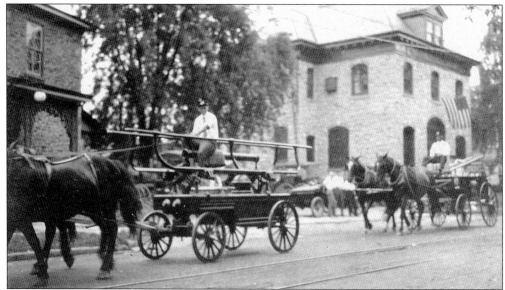

A number of newspaper articles and the minutes of the Avondale Fire Company confirm that the fire company made several attempts at reorganization between 1894 and 1900. A program from November 5, 1897, indicates that a "Children's Grand Carnival of Novelties" was held at Watson's Hall for the benefit of the fire company. The above photograph depicts horse-drawn fire apparatus in a parade, proceeding south on Pennsylvania Avenue, which opened a carnival in 1923.

At their July 1956 meeting, the fireman of the Avondale Fire Company presented the keys to the new grass-fire truck to the company's officers. The truck, built by fire company volunteers, saved the company an estimated $4,000. Shown at the presentation from left to right are (first row) Edward Harper, Gerald Kilmer, John DiCecco, Maurice Pickel, Harold Smith, and Roy Eller; (second row) Augustine Testa, James Rea, Clifford Kay, Richard Posey, James DiCecco, and Rondel Nichols.

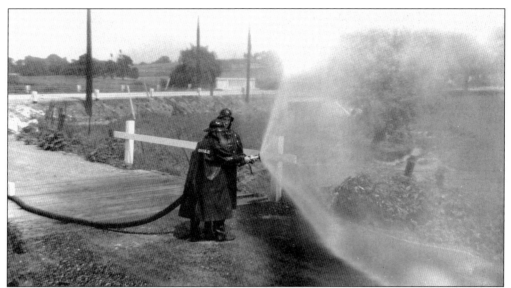

With the formation of the Avondale Water Company in 1901 the Borough of Avondale, in conjunction with the Avondale Fire Company, installed fireplugs in the borough. There were 10 double-nozzled Ludlow automatic fireplugs placed at street corners so that 300 feet of hose could reach any building. Standard thread connections and nozzles were adopted to facilitate cooperation with neighboring fire companies. A reservoir was built on Cook's Hill at an elevation of 125 feet above the level of the White Clay Creek, thus giving a maximum pressure of a little more that 50 pounds per square inch. Both photographs depict the fire company. In the photograph above, firemen are testing hose pressure on Ellicott Avenue in 1943, and in the photograph below, fireman are shown in action at a fire on Church Street in the early 1940s.

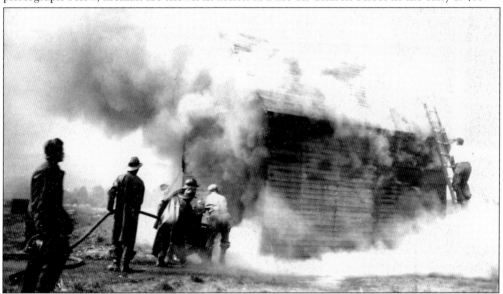

At a meeting in August 1933, the Avondale Fire Company considered the purchase of a new and lighter fire engine to complement the large 1923 American LaFrance engine they presently had. A committee was appointed to investigate various equipment and to make a purchase. The new Indiana fire truck had dual pneumatic tires, 500 feet of one-and-a-half-inch hose, 800 feet of three-inch hose, and a 200-gallon water tank; it arrived in early 1934 at a cost of slightly less that $3,000. The truck is pictured above in 1944 with, from left to right, Clifford Kay, Maurice Pickel, Augustine Testa, Gerald Kilmer, and unidentified. The photograph at left depicts the Avondale Community Honor Roll in 1946, once displayed at the municipal building, honoring those who had served in the armed forces during World War II.

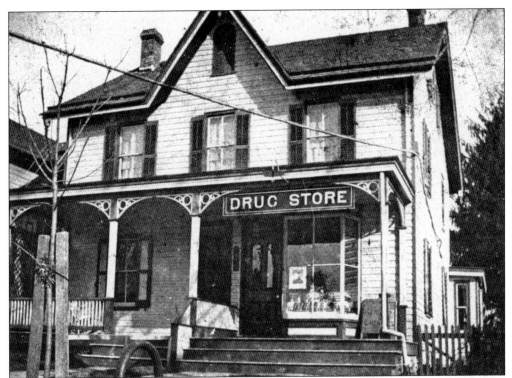

Charles Megilligan established his drugstore in Avondale in September 1882. Following his sudden death in 1890 his widow, Hettie Y. Megilligan, continued to operate the store. In 1900, she moved the business from the Allen Block to this building that was located on the east side of Pennsylvania Avenue next to the former Avondale Fire Company. Hettie operated the pharmacy until she retired in 1914 and sold the stock and fixtures to Thomas C. Marshall. The photograph above depicts the drugstore in 1905. The photograph below is of a trade card from 1888, issued by Charles when his drugstore was located in the Allen Block.

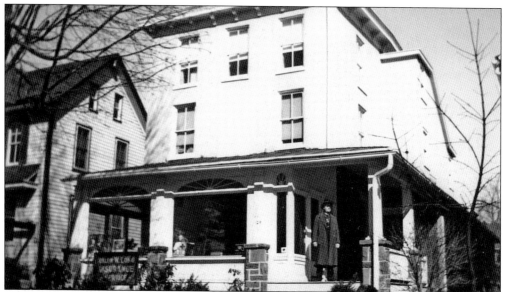

Anna Maria James, widow of John James, who was a partner with John Carlile and James Watson in the Avondale Iron Foundry and Machine Works, purchased this brick home and lot located on the east side of Pennsylvania Avenue between Second Street and the Lamborn Block in April 1872 from James Watson. In May 1940, Ralph W. Long opened his insurance service in the building. Stephen H. Watson purchased Long's business in February 1947, and the business became Pusey, Brosius, and Watson in January 1948. The photograph above shows the building and Ralph W. Long in 1942, and the photograph below depicts the interior of Long's Insurance Agency on the day it opened in its new location in May 1940. Pictured from left to right are Ralph W. Long, unidentified, and Anna Steel Sproat.

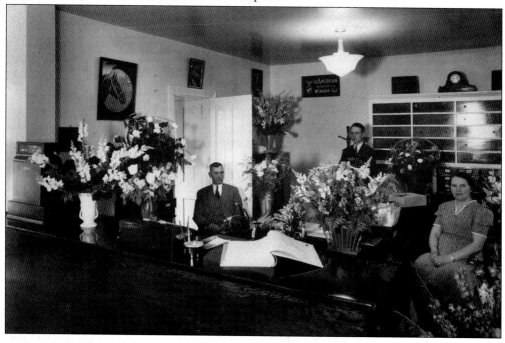

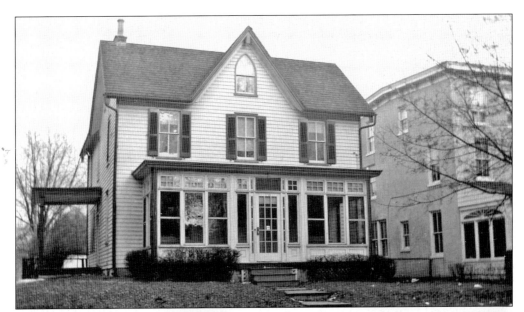

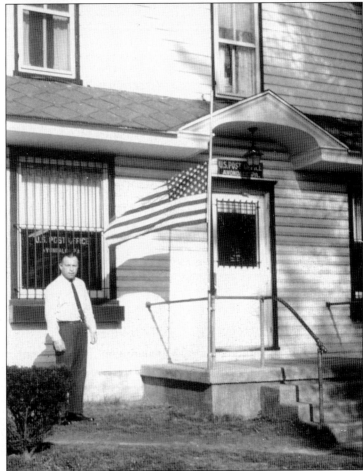

This residence, located on the southeast corner of Pennsylvania Avenue and Second Street, was built in December 1871 by Susan Wiley and Maggie Cope on land they had purchased from James Watson in April of that year. The two sisters operated a millinery and notions store in this home for many years. The building later served as the Avondale Post Office from 1941 until 1968. The above photograph depicts the home in 1939, and the photograph at right pictures postmaster Gerald Kilmer and the front of the building as it looked in 1965.

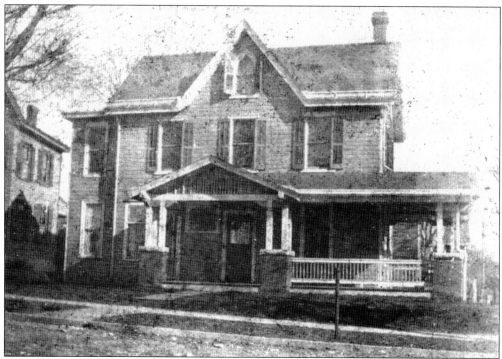

Located on the northeast corner of Pennsylvania Avenue and Third Street and shown in an 1892 photograph, this home of Dr. R. Howard John, a dentist, was purchased from Elias Sharpless in 1881 to be John's residence and professional office. The photograph below depicts the same building in 1942. The large building in the rear of the home, which replaced a frame stable, was built in 1908 when U. Grant Gifford, M.D., was the owner of the home. The upstairs of this building was used for dances, suppers, and social and charitable events by the Avondale Presbyterian Church, of which Gifford was a member. Over the years, the building has served as both a home and professional office for three dentists and four physicians.

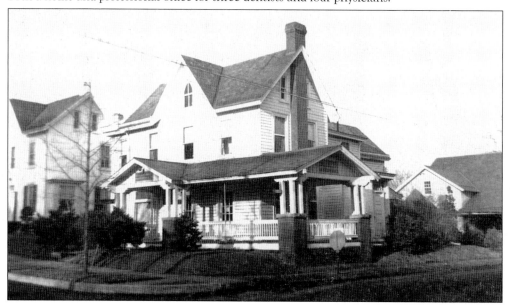

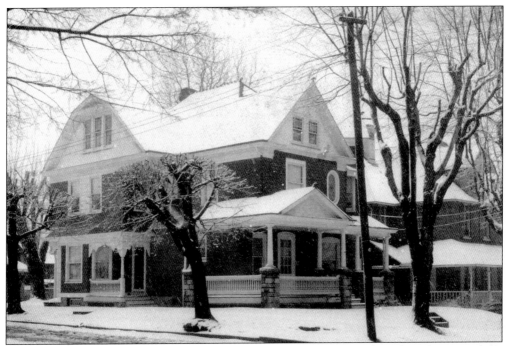

Maggie Taylor, widow of Samuel Taylor, who had been the local blacksmith and owner of the Avondale Wagon Works, sold a lot and frame dwelling, which fronted on Fourth Street, to James C. Pusey in May 1898. Pusey had the frame dwelling moved to the southeast corner of Fourth and Morris Streets and began construction of this brick residence, which was completed in 1901. The photograph shows a 1952 view of the residence.

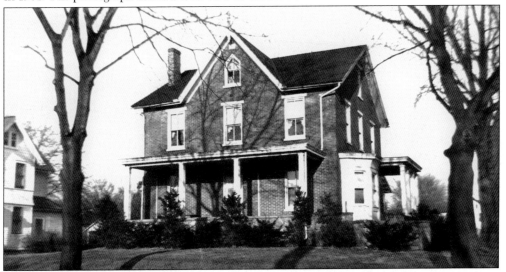

Dr. Henry C. Wood, a homeopathic physician and surgeon, purchased a lot on the northeast corner of Pennsylvania Avenue and Fourth Street on November 2, 1871. By the end of December of that year, he had built this building for use as his residence and medical office. In 1874, Wood relocated to West Chester, and the home was sold to Elizabeth Wood. On June 11, 1969, the building was purchased by the Avondale Church of Christ to be used as a house of worship. Today it is a private residence. This photograph depicts the building as it looked in 1943.

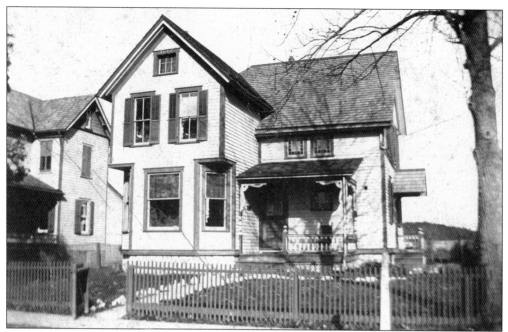

Humphrey M. Carpenter, a professor of music at West Chester State Normal School and Avondale postmaster from January 1886 until May 1889, purchased this residence located on the east side of Pennsylvania Avenue between Fifth and Sixth Streets in 1902. The residence was built in 1893 by Eliza Slack, who had purchased a parcel of land from Herbert K. Watson in 1892. This photograph depicts Carpenter's home in 1905.

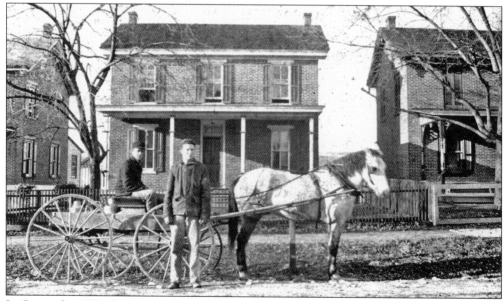

In September 1874, Benjamin Lamborn began building a house located on a lot on the east side of Pennsylvania Avenue between Fifth and Sixth Streets that he had purchased from James Watson for $200. The home was completed in November 1874. The photograph depicts Raymond Cleveland (left) and Charles Cleveland on Pennsylvania Avenue in 1908 with the wagon belonging to C. Y. Wilson's store. The Lamborn house is to the right of the photograph.

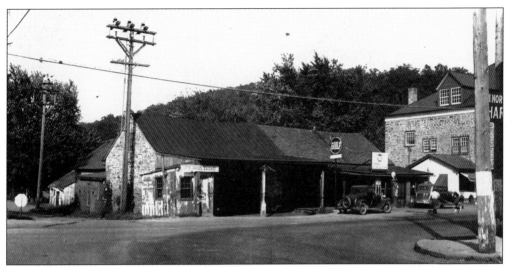

Located on the southeast corner of Pennsylvania Avenue and Front Street (now First Street), this blacksmith shop was built prior to 1840 when the property was part of the Ellicott Farm. The Avondale Post Office was located here from May 4, 1847, until March 18, 1852, under postmaster and resident blacksmith Levi Barnett. In March 1871, Samuel Taylor purchased the property and established the Avondale Wagon Works. The photograph shows the blacksmith shop in 1936.

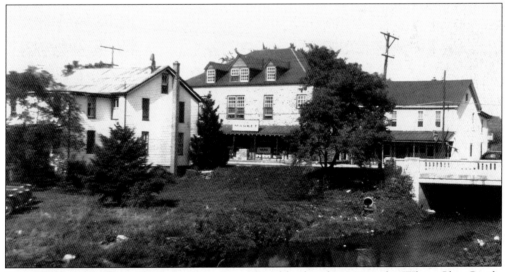

This 1945 view, looking northeast from the railroad bridge that spans the White Clay Creek, depicts both the GAR building on Pennsylvania Avenue and the Watson Block, which at the time contained Watson's Coffee Shop, Watson's Market operated by Frank Morris, and the state police substation. The concrete bridge had replaced an iron structure erected in 1901–1902 by Chester County. Today a service station occupies the site of the Watson Block, while the former GAR building has become retail space and an apartment.

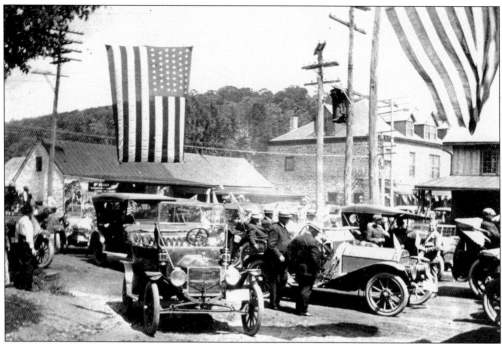

In 1911, the Pennsylvania state legislature passed the Sproul Bill, which made appropriations for maintaining public roads and gave each locality within the state a pro rata share of benefits. One such highway was Route 131, Pennsylvania Avenue in Avondale, which stretched from Philadelphia to the Maryland state line. Avondale was still waiting for the road improvements in 1915 when they welcomed state road commissioner Robert J. Cunningham. A large banner bearing the inscription, "Avondale Welcomes Route 131" was posted across Pennsylvania Avenue from the Watson Block to the garage of H. R. Pusey. Cunningham arrived with a procession of 100 cars and spoke of his agreement that Avondale needed the improvements. The above photograph pictures the arrival of Cunningham's entourage, and the photograph below depicts the banner mentioned in this caption. Both photographs are from 1915.

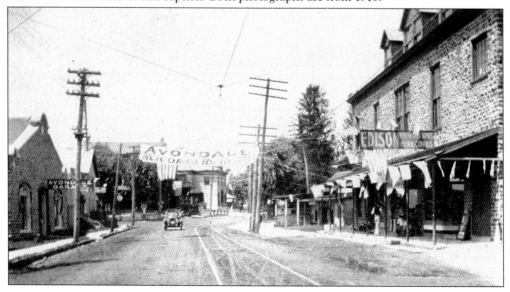

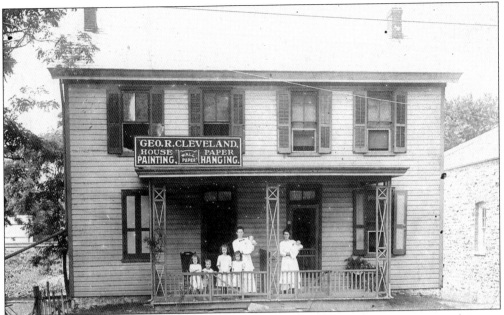

In May 1873, this building was moved from the south side of State Street to its present location on the west side of Pennsylvania Avenue next to the White Clay Creek. When this July 1913 photograph was taken, the residence was occupied by the George R. Cleveland and Nathaniel R. Watkin families. Pictured here are, from left to right, Wilhelemene, Herbert, Aletha, Evelyn, and Lotta Cleveland, holding Edith Watkin, and Philena Watkin holding Nathaniel Watkin.

Henry R. Pusey and Company built this stone garage located on the west side of Pennsylvania Avenue just below State Street in 1911. H. L. McLimans of West Grove was the general contractor and Owen Hoopes of Toughkenamon did the carpentry work. At the time of the construction, Henry R. Pusey and Company was the local representative for the Studebaker Motor Company. Pusey's motto was "Everything for Every Season for Every Farmer." The building is pictured in 1942.

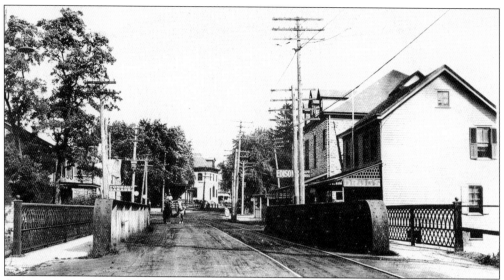

At one time, Avondale was known as Stone Bridge. The name was derived from the stone bridge that spanned the White Clay Creek (Miller's Run) on Pennsylvania Avenue. A wooden bridge was installed in 1873. In 1901–1902, a new iron bridge, 65 feet long with 5-foot pedestrian walkways on each side, was built by Chester County. This 1911 photograph depicts Pennsylvania Avenue looking north and the aforementioned bridge.

The electric transformer, shown in a 1941 photograph and located just south of the former Raymond Rosazza's garage on the west side of Pennsylvania Avenue, was the original location of the Avondale Brickyard, which was in operation prior to 1850. In the late 1860s and the early 1870s, the brickyard was operated by Charles Burleigh Jackson, an African American, and his two sons William and Robert. An electric substation continues to occupy this site.

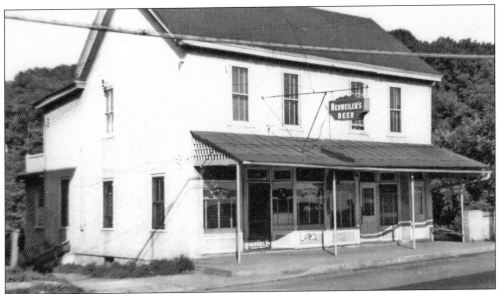

Originally the location of the tailor shop of Christian Ditzler, built prior to 1872 and located on the east side of Pennsylvania Avenue and on the north side of the White Clay Creek, the building pictured above in 1944 was purchased by the Bernard Gause Post No. 34 GAR in March 1887 for use as their post headquarters. In October 1909, the building was sold to Hannah Quarll Mackey for $2,260 and used by her son J. Quarll Mackey as his drugstore. In March 1916, Joseph Demicis purchased the building and operated a restaurant for a number of years. The building below, pictured in 1947, also located on the east side of Pennsylvania Avenue but on the south side of the White Clay Creek, was the location of a restaurant, bar, and pool hall operated by Alfred Cordivano in the late 1930s.

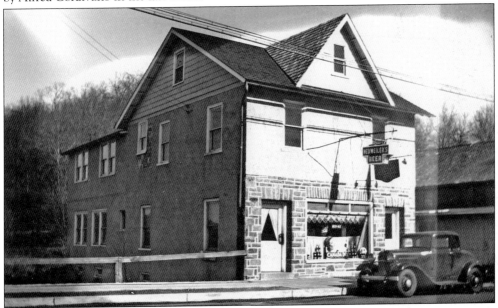

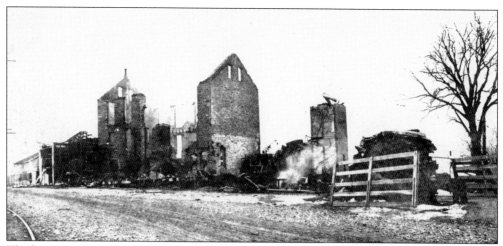

The large stone warehouse built by Samuel Morris on South Pennsylvania Avenue in 1860 and containing the "Stone Hall" on the second floor used for community events, was occupied in the 1870s by Richard B. Chambers's tinsmith shop and the furniture warehouse and undertaking establishment of William Hopper. The Avondale Ice and Cold Storage Company purchased the property in 1895, providing cold storage capacity and producing 15 tons of ice per day. The plant was sold in February 1899 and soon after purchased by William Turner and Elwood Pusey for use as an abattoir (slaughterhouse). Fire destroyed the abattoir in March 1905. In the photograph above, the burned abattoir is depicted in 1906, and the photograph below depicts the residence of Emmor Wood on South Pennsylvania Avenue, built in 1903, on a portion of the abattoir property.

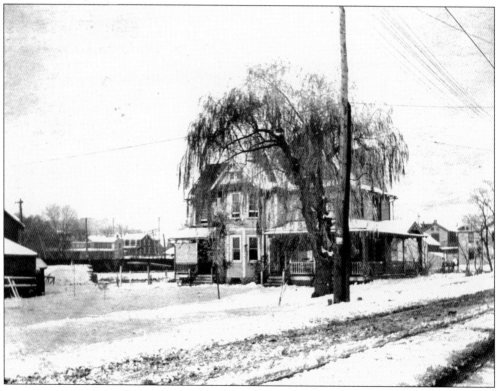

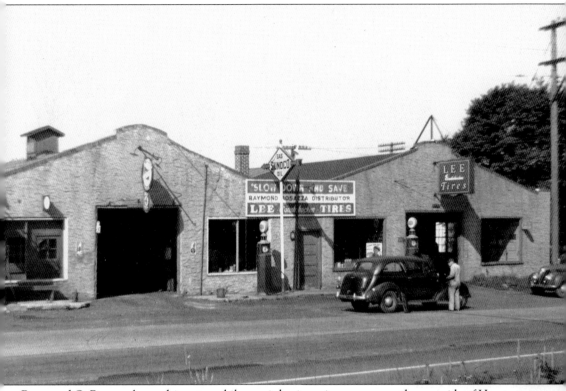

Raymond O. Rosazza began his automobile repair business in a garage on the east side of Hoopes Alley. In 1918, he moved his business to the former James McKenna blacksmith property located on the northeast corner of Pennsylvania Avenue and Church Street. In February 1920, Rosazza purchased from the Supplee-Willis-Jones Milk Company a garage and two tracts of land located on the west side of Pennsylvania Avenue, which had been part of the former Avondale Ice and Cold Storage Company and the Turner and Pusey Abattoir property. The photograph above is Rosazza's Garage in 1943.

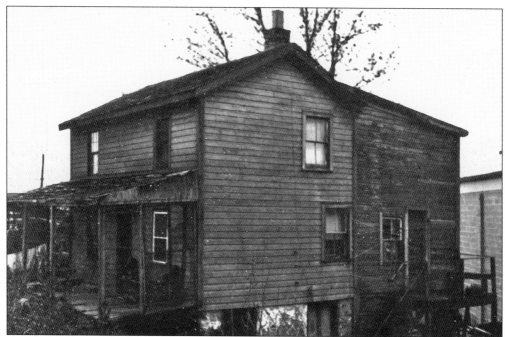

This home, formerly located on the east side of Pennsylvania Avenue near Church Street, was built in May 1883 for use as the residence and medical office of John S. Hudders, M.D. The property was originally purchased by Florence Phillips in November 1879 from James Watson. Hudders practiced medicine here until his death in 1891. In 1896, the property, which contained the house and an adjacent blacksmith shop, was sold to James McKenna, a local blacksmith.

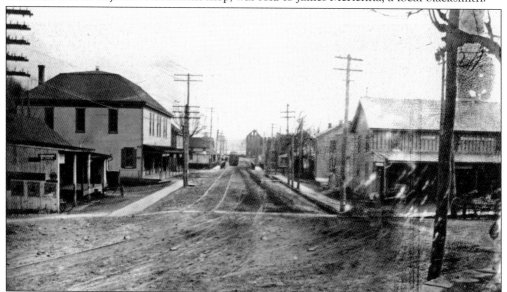

This photograph of South Pennsylvania Avenue was taken from the corner of the Avondale Hotel in 1906. The trolley can be been seen at the center of the photograph. At the left, from north to south, is the blacksmith and wheelwright shop, the Watson Block, and the GAR hall. At the right, again from north to south, is the frame agricultural implement warehouse of Caleb Cooper and Henry R. Pusey, two residences, and the burned walls of Turner's abattoir.

The Gap and Newport Turnpike Company, which was chartered in 1807, was composed of stockholders who held yearly elections for a president and 12 managers. The turnpike was completed in 1818 and operated as a toll road until 1838 when it became a public road. A stone tollhouse for the gatekeeper, the first gatekeeper being Hannah Chandler, stood at the east end of a narrow wooden bridge that crossed the White Clay Creek next to where Church Street is located on the east side of the present Pennsylvania Avenue. The above photograph is a view of the Gap and Newport Turnpike looking north into Avondale in 1896. The photograph below depicts the turnpike also looking north into Avondale in 1941.

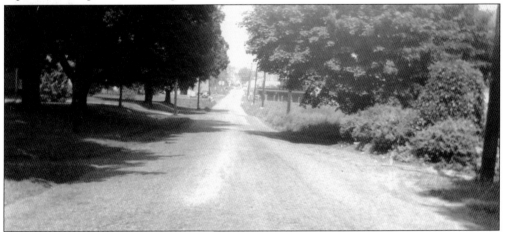

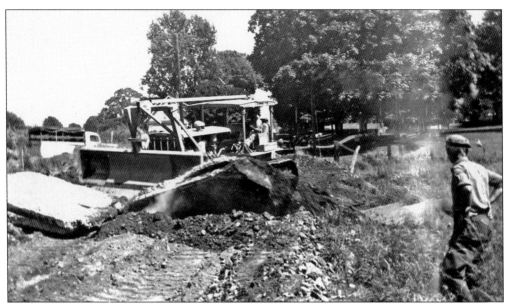

The Pennsylvania Department of Highways sought to improve the surface of Route 41 from near the former garage of Raymond Rosazza on South Pennsylvania Avenue to the Delaware state line by eliminating the dangerous curves and grades. The new improvements also included two new concrete bridges. Work began in June 1941 and was completed in October 1941. The photograph above depicts the beginning of the construction in 1941. The photograph below, also taken in 1941, depicts a portion of the newly constructed roadway at its intersection with Route 1 on South Pennsylvania Avenue. The Superior Canning Company is to the left of the photograph, and the barns of the Ellicott (Miller) property are in the background.

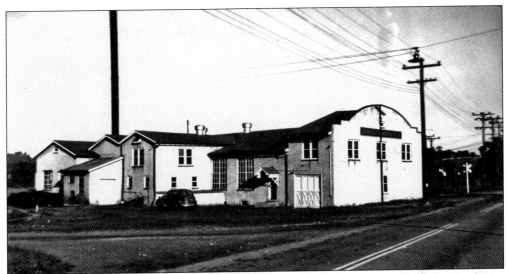

In 1940, Oreste and Valentino Catena were operating the cannery located on the northwest corner of Pennsylvania Avenue and Ellicott Avenue, when it was known as the Superior Canning Company. The Catenas had established the business in 1935 and employed 75–80 people during the peak mushroom growing seasons. The photograph depicts the cannery in 1948.

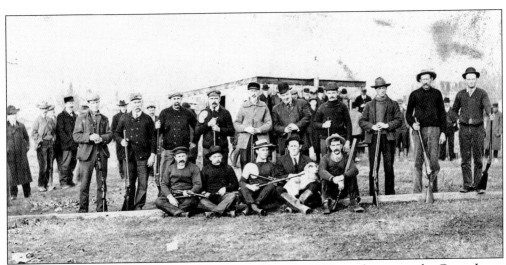

Prior to 1906, the Avondale Gun Club, pictured here in 1910, was known as the Green Lawn Gun Club and was formed for target and trap shooting competition. Pictured are, from left to right, (first row) Joseph Gray, Josephus Cox, William Megilligan, Bayard Fisher and Bandit, and Frank King; (second row) Edward Greenfield, William Search, Oscar Kramer, John Logan, U. Grant Gifford, George Magraw, Benjamin Fernan, Charles Kelley, George Cleveland, and Robert Mackey.

The Philadelphia and Baltimore Central Railroad quarry was located on the east side of the present Baltimore Pike beginning at the southeast corner of Church Street and extending southward along the then State Road toward New Garden Township. The original quarry property contained a little over 10 acres. Research has failed to indicate if the railroad owned the quarry or the number of years it was under railroad operation. Both *Witmer's Atlas of Chester County* in 1873, and *Breou's Farm Maps of Chester County, Pennsylvania* in 1883 indicate that the quarry was under railroad use. The two photographs depict the quarry in the early 1940s, when William N. Worrall of Kennett Square owned and operated the Avondale Colonial Building and Flag Stone Company.

William Larkin and Irwin Foote formed the Avondale Maverick Club in April 1900. The group entertained patrons at Watson's Hall and later at the Avondale Lecture Hall on State Street. This 1901 photograph shows the group's nine original members, from left to right, (first row) John Foote, William Matson, Frank Dinmore, and Irwin Foote; (second row) William Larkin, Leander Smith, George Abbey, George Miller, and William Jarrett.

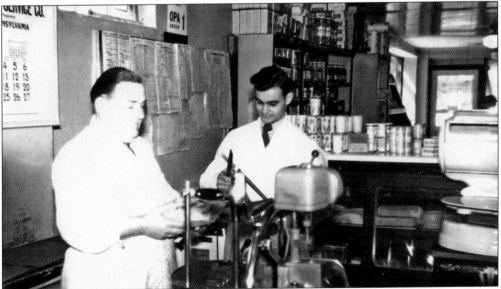

Frank McGurk (left) and Guido Fecondo are shown in this 1946 photograph of the interior of Fecondo's Quality Market located on the east side of Pennsylvania Avenue in the south end of the building occupied by the Avon Department Store. The market opened for business in 1946 and moved to the former Wood and Lamborn Building in 1951. In 1958, the market was sold to Richard Probst.

In November 1863, Josiah Phillips purchased "all that large Plantation and Tract of Land Situated in the Townships of New Garden and London Grove known as 'Avondale' containing 711 acres" from William M. Ellicott. Phillips sold the parcel in December 1863 to Benjamin F. Wickersham, who sold some parcels of the land and then later sold the remainder in May 1865 to John Yerkes and Chandler Hall (later Yerkes and George S. Jones). From those 711 acres, the town of Avondale developed. The photograph above shows a view of Avondale looking east from reservoir hill near State Street in 1941. The Avon Roller Rink can be seen to the left in the picture and the mill to the right in the picture. The photograph below shows a view of the town in 1947, looking southeast from the area that was to become Pomeroy Avenue.

Five
OTHER STREETS AND MISCELLANY

Pictured in 1942, along what is now Pomeroy Avenue, are pressure supply tanks that were located on the gas plant property of the Chester County Light and Power Company, successors to the Kennett Gas Company, which had supplied Avondale with gas for homes and for street lighting. In 1937, the old plant was completely dismantled except for the four tanks.

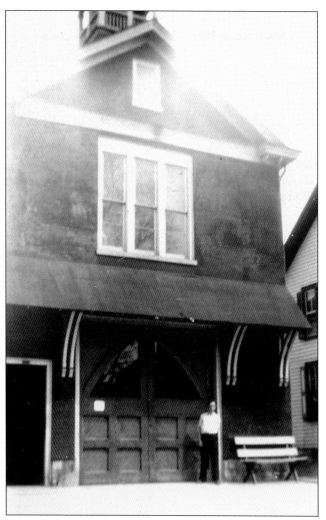

On June 12, 1894, Avondale Borough Council authorized the purchase of a parcel of ground from Herbert K. Watson, located on the east side of Chatham Street between Second and Third Streets for $190. In September of the same year, a bid was awarded for the construction of a municipal building and firehouse. At their February 1895 meeting, the borough council reported that the municipal building was completed and accepted, per the contract of $1,635. The building, now a private residence, was sold at public sale on March 30, 1937, after a new municipal building was erected on Pennsylvania Avenue. The photograph at left depicts the municipal building and firehouse in 1926. In the photograph below, William C. Mackey is shown at the municipal building in 1912 with the fire company's apparatus.

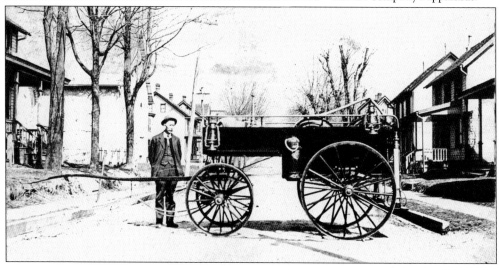

George B. Tucker, Samuel Bacon, William Brown, Moses Rhoads in 1869 and Isaiah Watson in 1871 were five African Americans who purchased land in New Garden Township from Cornelius O'Connell, in what is now Avondale, and settled into farming. These farms were eventually divided, parcels and lots were sold, and the African American community developed. These farms became what are now Henson, Thompson, Poplar, Maple, Minor, Spruce, and Church Streets, and the present Mount Tabor African Methodist Episcopal Zion Church. Watson was to become the first pastor of Galilee UAME Church. Pictured are two residences formerly located between Henson and Thompson Street on the east side of Church Street.

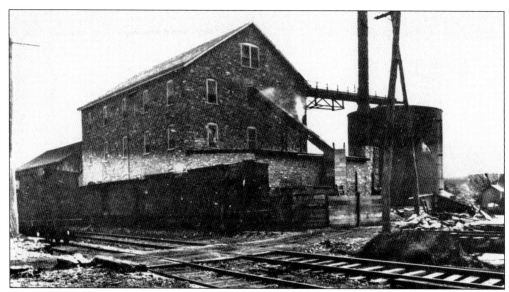

On April 1, 1868, George S. Jones sold to Joel B. Pusey and Joseph Barnard, trading as Pusey and Barnard, a parcel of land containing two to three acres. Situated on this land was an old steam sawmill and two frame dwelling houses. This parcel is referred to as the "Bark Mill Tract." In 1874, Menander Wood purchased an acre of the property, and in January 1883, Wood's son Morris sold the parcel to William J. Pusey and Warren R. Shelmire. Early advertisements state "Pusey and Shelmire: Flour, Feed, and Coal." The photograph above was taken in 1907 when Pennock and Brosius were operating the mill; the photograph below pictures a group of mill workers in 1905.

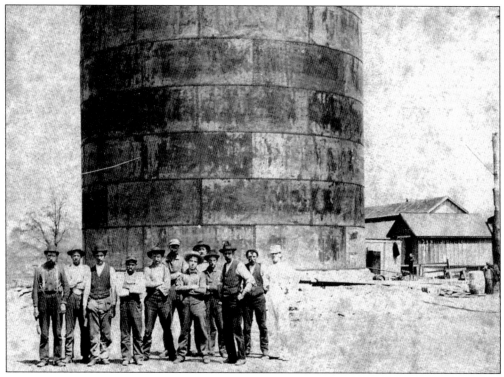

The Avondale Choral Society was organized in the fall of 1923 by W. Randall Skillen. Open rehearsals were held every Tuesday evening at the Avondale Presbyterian Church. The objective of the organization was the performance of both musicals and choral recitations. The above 1927 photograph of the cast was taken at the Choral Society's rehearsal of Gilbert and Sullivan's two-act comic opera *Pirates of Penzance*.

W. Randall Skillen, who had organized the Avondale Choral Society in 1923, began developing the Avondale Band in September 1926, and by December of that year, a small ensemble had been formed and began rehearsing. In February 1927, $1,000 worth of instruments were secured by the band, and its first public appearance was July 2, 1927. The band is pictured here in 1928 at the borough hall on Chatham Street.

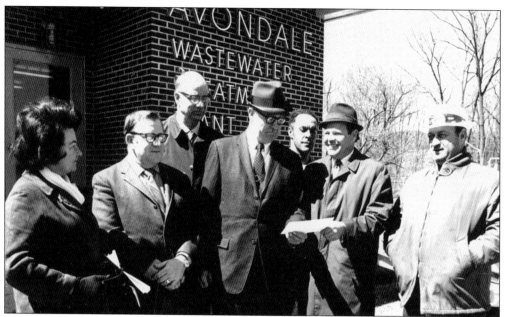

Avondale Borough Council first discussed a sewage disposal system for the borough at the August 1964 council meeting. In July 1965, an ordinance was adopted organizing a municipal authority to be known as the Avondale Borough Sewer Authority. In November 1966, the Avondale Borough Planning Commission approved a site for the plant on the former Avondale Iron Foundry and Machine Works property on the south side of State Street. Ground was broken for the plant in April 1970, and the plant was completed in March 1971. The photograph above depicts borough representatives receiving a check for $53,000 from the Pennsylvania Department of Environmental Resources to help finance the project. Pictured are, from left to right, Madeline Nicotera, Edward Harper, Benjamin Reynolds, Frank Perry, Philip Minor, Christian Beechwood, and Samuel Losito. The photograph below depicts the sewer construction on State Street in 1971.

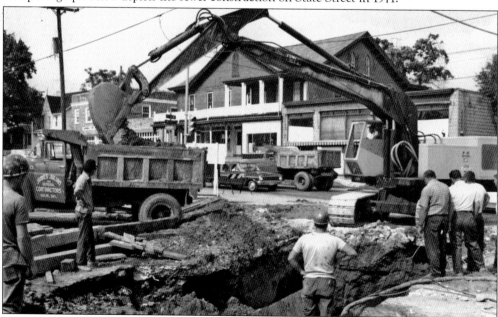

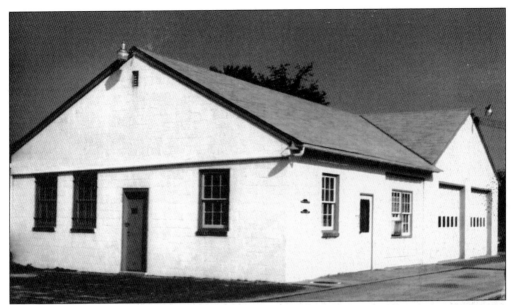

On October 20, 1950, the Borough of Avondale purchased property along Pomeroy Avenue "for the purpose of establishing and maintaining a parking lot and storage facilities for borough equipment." The following December, Passmore Supply Company of Avondale was awarded the bid in the amount of $913.84 to build a new borough garage on Pomeroy Avenue. Construction was completed in February 1951. Heat to the garage and jail was added in 1952 by Medford-Dunleavy, and in 1953, bids were advertised for the installation of borough scales and for a pit to be dug for the same. The building is still in use as the Avondale Borough Hall and Borough Garage. The above photograph depicts the borough building in 1970, and the photograph at right depicts the jail in 1954.

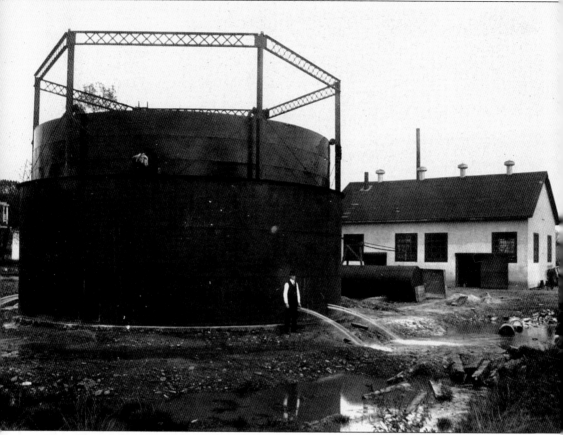

The Chester County Light and Fuel Company began constructing a gas producing plant, including a gas storage tank, and began laying gas mains for the purpose of light and fuel in Avondale in October 1906. The oil and pumping and other equipment for the manufacture of gas was delivered to the plant area in early April 1907. After that work was completed, the gas in Avondale was turned on for the purpose of lighting an experimental street light on May 27, 1907; however, the plant was not yet entirely ready to manufacture gas for patrons. In July 1907, the company began installing service pipes and meters to subscribers' residences and full service occurred in September of that year. In 1908, after the original business went into receivership and was sold at sheriff's sale, the Kennett Gas Company purchased it. The receivership documents mention a one-story concrete building, a one-story frame building, and a round iron gasholder. The gas storage tank pictured here in 1907 was demolished in 1937.

Before it was moved to Pomeroy Avenue in the 1950s, the Avondale Borough Garage and borough "lockup" was located at the rear of the Avondale Municipal Building, which fronted on Pennsylvania Avenue. Charles E. Cleveland, Avondale borough roadmaster, is pictured here in 1942 at the rear of the municipal building on Morris Street with the borough's 1928 Chevrolet dump truck.

According to the minutes of a meeting held in the Allen Block on November 19, 1888, a committee was appointed "to proceed to have one or more lectures in Lamborn's Hall" for the benefit of the fire company. This was the first recorded mention of fund-raising for the Avondale Fire Company. The photograph above depicts one such fund-raising event, a fair held in August 1966 at the corner of Pennsylvania Avenue and State Street.

Avondale Boy Scout Troop 3 was chartered by the Avondale Presbyterian Church in 1920 and met weekly in the church basement. Horace Pusey was appointed scoutmaster in 1940. Pictured in 1947 are, from left to right, (first row) Gary Windsor, Harold Conner, Robert Jenkins, Joseph Nigro, William Blittersdorf, and Thomas Rosazza; (second row) Horace Pusey, William Webb, Bayard Pugh, William Gregg, Kenneth Ross, Bud Miller, James Taylor, Carlos Trimble, and Loren Richards.

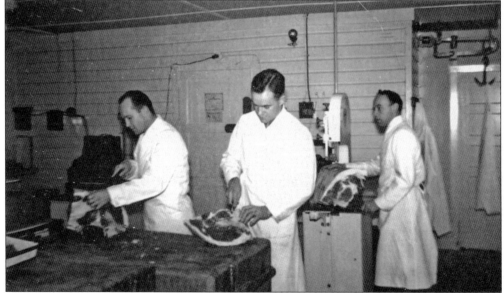

The Avon-Grove Freezer Service was organized in July 1948, with businesses located in both West Grove and Avondale. The owners at that time were Thomas H. McDowell, John R. Edwards, and Harold Davis. In July 1953, the partnership was dissolved, and Davis continued the business in Avondale as the Avon Freezer Service. Norman H. Smack purchased the business in May 1955. Pictured are, from left to right, McDowell, Smack, and Davis.

Arthur Crowell, pictured above in 1941 in his vehicle in front of the National Bank of Avondale, will be remembered as a frequent visitor to many area homes, using this unique vehicle to peddle apples from his orchard and to sell cider that he had pressed at his mill on Church Road in New Garden Township. John C. Mackereth is pictured in the photograph below in 1942, with his apiary at his home located on the northwest corner of Third and New Streets. Mackereth operated an apiary of approximately 24 hives. Both of these individuals contributed to the life of the community. Both Crowell and Mackereth were instructors for the agricultural classes of the Avondale Vocational High School. The classes studied apple varieties and orchard operation at Crowell's and beekeeping and honeybee culture at Mackereth's.

The land that today comprises most of the borough of Avondale was part of a tract of 711 acres known as Avondale, situated in both New Garden and London Grove Townships, which was conveyed to Josiah Phillips in November 1863 by William M. Elllicott as trustee for Sarah Ann Lindley, Hannah E. Gilpin, Elizabeth Pike, Lydia Turnpenny, Mary T. Ellicott, and Rebecca M. Ellicott, his six sisters, and also for Jacob Lindley, the husband of his deceased sister Catherine Ellicott Lindley. William had petitioned the Chester County Orphan's Court in September 1863 for the sale to Phillips, stating that all parties concerned agreed to sell and convey the property to Phillips for $85,000. The above photograph depicts the old stone barns on the former Ellicott property in 1942, and the 1944 photograph below depicts the lime kilns built prior to 1840, located on the same property.

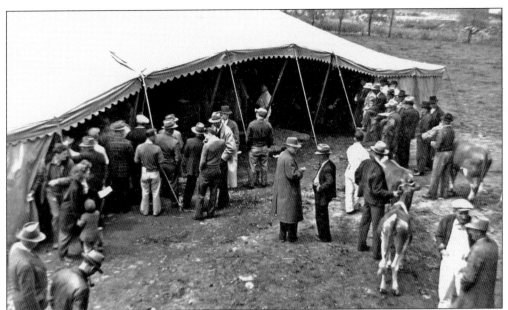

Thomas Ellicott and Mary Miller were married at New Garden Friends Meeting in 1806 and resided in Baltimore, where Ellicott was associated with his brother in the milling business. He was also president of the Union Bank of Maryland in Baltimore. In 1834, they moved to Miller's estate in Avondale. Newspaper articles indicate that the Ellicott's were noted for their picnics and tent socials while they resided on the property, and one account noted that a large meadow area was "a hub of activity for drummers." During World War II, the area was a center for community sales. Among the items sold were produce, household goods, and furniture, and livestock was auctioned. In August 1948, Maurice Stump began the Chester County Community Sale here auctioning livestock, furniture, and farm machinery and having concessions for fresh fruits and vegetables.

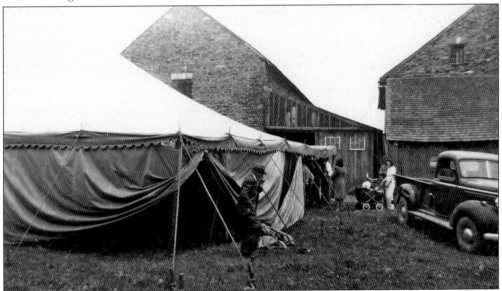

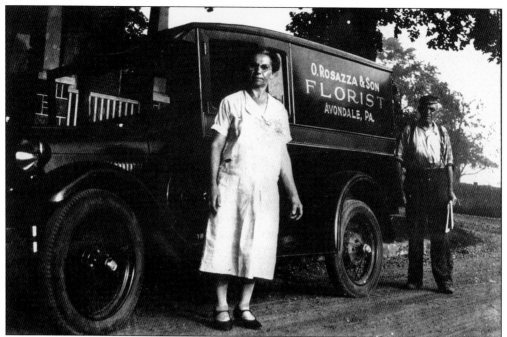

Louisa and Odone Rosazza established the Meadowside Greenhouses on New Street about 1900–1901. Odone, after emigrating from Italy, had been employed as a marble cutter for the Pennsylvania Marble and Granite Company in nearby London Grove Township. Their grandchildren and great grandchildren still own and operate the business. The Rosazzas are pictured here on New Street in the 1920s with their new delivery van.

This residence, located on the west side of Chatham Street next to the former Avondale Methodist Church Parsonage, was built in 1873 by John and Anna Maria James. In April 1874, John sold the home to Jacob Logan, a local wheelwright. The home remained the Logan residence until the late 1940s. Pictured here is Mary Pedrick Logan, widow of Chandler P. Logan, and her dog Beauty in May 1944.

Looking north from Watson Park toward Rosazza's meadow, this 1941 view is of the stone arch bridge that crosses the east branch of the White Clay Creek on East Third Street near Galilee UAME Church. Known as County Bridge No. 240, it was built in 1912 by D. E. O'Connell. The bridge is now part of Project Keystone, which is the Pennsylvania Department of Transportation's management plan for the 125 stone arch bridges in the Greater Philadelphia area of which this bridge is No. 041.

Elisha Tilghman Meloney purchased a lot located on the east side of Chatham Street, between Second and Third Streets, in January 1874 from James Watson. In 1875, he built this frame residence. In the 1890s, Meloney was both the tax collector and street commissioner for Avondale. The residence is pictured here in 1900 with Meloney's two grandchildren Laurence Anderson (left) and Gerald Anderson.

Across America, People are Discovering Something Wonderful. Their Heritage.

Arcadia Publishing is the leading local history publisher in the United States. With more than 3,000 titles in print and hundreds of new titles released every year, Arcadia has extensive specialized experience chronicling the history of communities and celebrating America's hidden stories, bringing to life the people, places, and events from the past. To discover the history of other communities across the nation, please visit:

www.arcadiapublishing.com

Customized search tools allow you to find regional history books about the town where you grew up, the cities where your friends and family live, the town where your parents met, or even that retirement spot you've been dreaming about.